Chrysanthemums

Under Streetlights

Chrysanthemums Under Streetlights

S. Savannah Verdin

QUERENCIA

Querencia Press, LLC
Chicago, Illinois

QUERENCIA PRESS

© Copyright 2022
S. Savannah Verdin

All Rights Reserved

LIBRARY OF CONGRESS CATALOGING-IN-PUBLICATION DATA

ISBN 978 1 959118 99 2

www.querenciapress.com

First Published in 2022

Querencia Press, LLC
Chicago IL

Printed & Bound in the United States of America

Every second,
every minute,
and every hour of everyday

I have the unique experience of knowing this story both from the viewpoint of an insider and an outsider. This book is a burning house waking you from dreams. It is crawling just under the flames but still choking on the smoke. It is the firefighters crying out to you to get to the window, only to find out that it has been barred over. It is dragging your sobbing body to the door, burning your hands at the knob, and rolling down the stairs to discover that the fire started on the floor below you, and is now raging. This is a generational, cyclical trauma trickling through these pages.

A large part of this novel deals with the trauma surrounding adoption, while the rest is a way of explaining that it is not a clean-cut subject. Many things (domestic violence, generational traumas, homelessness, illness—both mental and physical) led up to one of the most difficult decisions that any person could ever have to make, and in this case, the decision was made under forced ignorance and duress (one of the main aspects of duress is that it negates a person's consent, yet here we are, letting someone sign away their life without giving them alternatives and instead threatening them). There were parts of this story that I was very much present for and looking back and knowing how incapable I felt of helping, makes it difficult to separate my thoughts on the situation from my feelings on it. I think that is how we have to learn to read these stories, though.

Society has recently been breaking down in a way that leaves me waking every day more disappointed in it than I was when I

fell asleep the night before. Maybe that is because there was a small blip in time where we suddenly seemed to be taking so many progressive steps that were long over-due, and now all that work is quickly being reversed (not that there was much of it to begin with). People in power have become too powerful for the rest of us to make anything but dents in a system that needs to be cracked open wide. We need to stop living by the "ignorance is bliss" motto and start paying attention. We need to be educating each other on all the things that get swept under the rug. Just being able to empathize with someone is no longer enough because, as a whole, we have ventured so far off track. Being able to read this and feel the emotions being thrown at you is not enough. Being able to place yourself in the situation is not even enough. You need to place yourself in the aftermath. The navigation of the tragedy. We need to start learning to hear these faults in humanity in a way that helps us to not just understand the emotions they cause but to understand the responses and the ways and places that people are being left behind and overlooked. We need to start listening and committing to memory all of the whys, and then we need to start sharing that information every chance we get.

Savannah has created something beautiful by mixing poetic prose in with educational information that the majority of people do not have. There is an extensive amount of civil corruption revealed in this novel, but the most devastating moments are the ones where systems were manipulated to look morally upstanding from the outside but ended up being bankrupt. This is happening all around us every single second of every day, and we are being made blind to the machinations

through misdirection in disputes over one another's personal freedoms and preferences.

As a reader, I hope that you let this book swallow you. I hope it lingers. I hope that it pisses you off on behalf of anyone who has ever experienced the smoke and mirrors of the predator. I hope that you see the ploys before they are even explained. I hope that you do not stop at what is in these pages, because this is just a tipping point. This is just one person sharing the way the outside world coerced and changed and tricked her into things that she would have never chosen if she had been given all of the information.

Watching a person that I love struggle with a guilt she does not deserve has been one of the most uniquely hopeless situations that I have ever experienced. Savannah is deeply immersed in the fields of psychology and social services. On top of many other things, she is a peer mentor for NAMI, meaning she almost always has the language and the insight for everyone around her experiencing a trauma. There are too many days that I have to watch her triage her own traumas, watch her remind herself that she did not choose the things that happened to her, because we cannot give consent without being able to make an informed choice. There are too many days that I am afraid that she will not remember that, no matter how many times her or myself remind her of it. If someone this strong, with this much emotional knowledge, is struggling to make it through this, what is happening to the people who still do not understand that coercion is not consent?

That being said, just barely touching on the disparity of a typical adoption narrative—if the interactions that caused the traumas mentioned in this memoir were to happen between two individuals (not a giant organization funded by a capitalist agenda and a singular person), let's say a husband and a wife trying to leave him, we would look at it as a toxic relationship. People would be shouting about how she was manipulated, how someone lied, took advantage of a woman in need, and then all but kidnapped her children. Because it is an organization protected by systems of power, we are told to look and see the victim as the villain, the predator as the savior. When do we start listening to the stories happening in the background? What does it take to pull back the curtain in Oz and see that the big, floating head was just a distraction?

I want to give this book a microphone and blast it until the world's ears are bleeding, but most of all, I want you to start listening without the need for that amount of noise.

—Emily Perkovich

There's a Story Behind Every Choice

The only dead-end for these words exists in the spaces of time where I abandon a voice I've muddied my hands to find. Even scrawled across pages with no direction, it's my voice. And just like any other tool, there's a needed strategy while using it.

I've worked in mental health and social service settings for about six years. Every role benefits the role after in terms of awareness and tact. Early on I experienced trial and error with case notes, end of shift reports, and progress reports, depending on the employer's preference. In the beginning it was hard to differentiate what was appropriate to share and how specific to write. But there was a commonality—if it wasn't documented, it didn't happen, so I documented everything in whatever form necessary.

The documentation needed is a lot like the navigation of writing these words for the purpose of this book. I'm approaching it with mindfulness, and I have no intention of speaking for anyone that was involved in these experiences. My goal here is to share my experience in those moments. In my younger years I didn't have the language to understand or describe what I elaborate on here. I had desire to understand, but without the language the desire is a dormant situation. I wanted to name every bad thing I'd ever witnessed, whether firsthand or otherwise.

I need to write this. I'm writing this because there are too many injustices that need a voice. I'm writing this for all the silent sufferers. I'm writing this for survivors of any kind of violence

anywhere. I'm writing this for separated families and individuals who are oppressed in systems that weren't built to serve them. I'm writing this for those of us who needed a trauma informed environment and were given shame instead. I'm writing this for the sake of my own mental health and the stigma attached to mental illness. I'm writing this for everyone walking their own path of recovery. I'm writing this for those who turned to a substance for comfort, when the root of pain stems from prolonged unaddressed trauma, mental illness, grief, basic needs not being met, and all the reasons society doesn't connect to "drug abuse." Did you know that substance use disorder is in the DSM-5? If you aren't familiar with the DSM, it is the diagnostic and statistical manual of mental disorders. It's used by health care professionals in the United Sates and much of the world as a guide to the diagnosis of mental disorders. It contains descriptions and criteria for diagnosing. I'm writing this because unless you're directly in the field of psychology or undergoing treatment you may not know that substance use isn't as black and white as society makes it out to be. But this isn't an excuse. It is an explanation that pleads for compassion. It's a relentless battle. I'm writing this for homeless communities who are more generous than most housed people I've met. I'm writing this because everyone deserves a home. I'm writing this because someone won't have a bed tonight. I'm writing this because of the stigma that suggests homeless people are "druggies." I'm writing this because the world needs more compassion. I'm writing this because I am someone who understands. I'm writing this because I'm someone who experienced homelessness while working as a mental health peer and I know what it's like to be thrown out of gas station bathrooms

in the morning before I got dressed for the office. I know what it's like to be treated like filth on the ground by society. And I also know what it's like to wear a blazer two hours later. I slipped into a business casual attire and those same gas stations smiled and welcomed me. I'm writing this because this is a perspective I need to share. I'm writing this because I know my own recovery has felt like healing earthquakes as they are still happening. I'm writing this because I have the language now. I'm writing this because the truth still exists even if we don't say it. But if I don't document it, I leave an opportunity for others to say it didn't happen.

Do·mes·tic Vi·o·lence

Domestic violence is defined as violent or aggressive behavior within the home, typically involving the violent abuse of a spouse or partner.

Domestic violence is what happens when the abuse is in the victim's intimate circle. This includes partners and ex-partners, immediate family members, other relatives, and family friends. The term 'domestic violence' is used when there is a close relationship between the offender and the victim.

There are three phases in the cycle of violence: (1) Tension-Building Phase, (2) Acute or Crisis Phase, and (3) Calm or Honeymoon Phase. Without intervention, the frequency and severity of the abuse tends to increase over time.

Abuse victims can suffer both short and long-term emotional and psychological effects, including feelings of hopelessness or confusion, depression, anxiety, panic attacks, post-traumatic stress disorder (PTSD) and complex post-traumatic stress (CPTSD)

In addition to emotional and psychological impact, this abuse contributes to chronic health problems later in life. It also causes victims harm by effecting care for any preexisting health problems and worsening those problems for the victim. Furthermore, the abuse can result in substance use as well as other unhealthy coping skills that deteriorate victim's health and quality of life.

Risk factors can include poverty, family violence, exposure to media violence, and oppressed groups in our communities

among other factors. However, this violence can occur anywhere within any gender, economic status, race, etc. Yet, there is *NO* excuse for violence. Violence is about power and control. Yes, there are factors that elevate risks but that doesn't eliminate the accountability for perpetrators or exclude anything or anyone outside of these listed risk factors.

Start From the Beginning

First Take

I'm a nineties baby

In my childhood home we created our own reality and the lines in our biology cultivated a tolerance for violence. We didn't question it. We didn't tell anyone. We didn't talk about it, not even with each other. I still cover my face with a pillow today. It was a tool I used when screaming was more violent than usual. Nonetheless, the screaming was the baseline, and this part was as common as a Monday. I know this isn't normal now, but we didn't question it before. We didn't tell anyone. We didn't talk about it, even with each other.

In my childhood home we used bed sheets for curtains. We didn't have a basis for comparison. We were isolated in this circular pattern. What happened within our walls stayed there. We buried the hurt I couldn't yet identify, deep in our bones and carried it as silently as possible. We didn't talk about it. *There weren't elephants in the room.* My parents didn't want animals inside. Even if the animal was as secret as the violence, it wouldn't erase the truth that they're filthy and unpredictable, like violence itself. And yet, the violence was allowed.

In my childhood home we loved our mother and father, but we moved with deep consideration of their possible reactions. My father worked on a boat. My mother slept a lot, and I'm still not sure if the sadness was because of the sickness or if the sickness was because of the sadness. When my father came home his boots were as murky as the bayou waters he traveled. Somewhere along the way the screaming would start. I didn't have the language to describe the silence beforehand, so it felt like a calm I shouldn't disturb with a thought, or feeling, or even

a cough. If you asked me today, I'd call it eggshells. If you asked me today, I'd call it tension. If you asked me today, I'd know it was unhealthy. We believed that was just how it was. We didn't understand violence. We didn't understand what it meant for a home to be a home. We didn't know sheets weren't curtains, and even if we did know these things, we didn't question it. We didn't tell anyone. We didn't talk about it, not even with each other. If you asked me today, I'd relate it to poverty. If you asked me today, I'd dissect poverty's connection to abuse and abuse's connection to other life stressors within that. If you asked me today, I'd think about every therapist I've ever had. I'd remember the safety of those spaces and what it was like to find that I have a voice. And if I just so happen to say these things out loud, I'd remind whoever listened to me that there isn't an excuse for violence and that violence is a choice. But only if you asked me today.

Because in my childhood home it was just the alcohol, it was just the bills, it was just the weather, it was just the noise, it was just a bad day, it was just an accident, and if I continued this would just be a long-unhinged sentence. I hope this conveys my point. I really want to explain that I didn't know sooner. I really want to explain that I wouldn't know what to do with it even if I did know that young. But I knew that we didn't question it. We didn't tell anyone. We didn't talk about it, not even with each other.

For Mom:

We're More Than the Cycles That Precede Us

I can't sandbag these words enough to triage the flood that
violence has been. In the common ways violence feels like
love, I don't know where to begin. First, it makes sense to
remind you that violence isn't love. I've had people in the past
remind me with the same words until I woke up one day and
realized love shouldn't hurt. I stared at my reflection holding
that truth and questioned the dirt that's been burying my self-
worth. Mother, I want you to find your wings too. Every day I
wrestle with myself knowing that you're sitting in the ashes,
but this isn't just guilt, it's the desire to break the chains
holding you captive. But just like I couldn't leave until I was
ready, I know the same is true for you. No one can pick you up
and carry you away from the crime scene that love has been
until you decide that you're through. Even through the weeping
violins of my heart, I can't save you. I've battled myself
enough in my own transition to know that we can't skip steps
in the process of being free. Even the advocates that sat with
me during court hearings couldn't do the work for me. I still
can't triage these words enough to know if I'm saying this
right. But I love you. And I'm still learning how to fight. The
violence is still an injury I'm healing from. Maybe at least you
know you aren't the only one? Maybe if you feel less alone you
can unbury your worth and fully see your reflection? You are
more than that burning home you've been left in. The world is
larger than what you can see. And once you fly away just know
you're doing it for us too, you're doing it for me. This is how
we heal our sick and dying family lineage. We are more than a
tribe of centuries of violence. One after the other, the wheel
spins out new versions of hurt, but mother please unbury your
worth. Mother, please, I'm asking you to see who you are

outside of these chains. This isn't one of those things that you can dance with in the rain. Because this isn't just rain, it's a raging storm sure to cause more casualties than it already has. The fire is getting out of control. We're way past the alarms and the red flags. Fear has been hands around my neck even as I'm free because you haven't left. The pain you sit with regularly is hard to accept. We can love the people who aren't good for us and still walk away. You are allowed to live your life. You are allowed to be safe. But I know you are also allowed to do things in your own time. You're living through something only you can define. And this decision should be made from a place of empowerment and not obligation. It's your choice. It's your choice. So, tell me when. And though I know my experience in this, your experience is still yours alone. I just want you to know that you deserve peace and a safe home. It isn't your fault. No one deserves to be hurt, so until you're ready to go, I'll remind you of your worth. Because mother, I learned why the caged bird sings. Mother, I believe in you. I hope you find your wings.

Bambocheur

I'm a nineties baby

I'm arguing with the devil again.
He's in a rocking chair beside the bayou mocking my faith.
I'm stooping to his level again,
with a zydeco soundtrack,
and thirty-two shades of hate.
Bayou waters host a place where the secrets of
native anger hides in a growing family lineage.
Hush little baby don't say a word,
but I never knew how damaging it was to give violence silence.

The Burning House

The Years in the Fog

Why didn't you just leave? The apartment was hot. I felt the sweat on his forehead. Maybe the apartment was hell, but it wasn't a question as much as it was a steady ponder. The last drop of hope had fallen. The hope was that it was only a lie. Even when reality painted me shades of crime. There I was, tunnel-vision falling into the red and blue of siren lights. There I was, hoping it was a lie. There I was, searching to rewind. There I was, remembering the synchronization of vows freshly shared. And there he was. Midnight stirred in his soul. Darkness spewed out of him, as though the gates of hell learned how to invade homes in the form of husbands. One, two, three, four, five, six, seven, time fell as still as a dormant truth.

With one hand on the wall to my left and the other holding a golf club to my throat he pressed his forehead to mine. He raged demonic spell while he reminded me that I was worthless. I remember hearing our son whimper lightly in his crib. We were right beside his doorway entrance, and we were disturbing his sleep. The demonic thing that seemed to no longer be my husband repeated, "What are you going to do," over and over like a challenge I didn't want to accept. I knew I was powerless.

I apologized through choked tears and breath. I apologized for knowing about his messages to other women. I apologized for the dating site he joined just a week earlier. I apologized for not trusting him even while my instincts were right. I apologized for asking him about it. I apologized for feeling hurt. I apologized for ever existing that day. I didn't know what to do aside from yelp out apologies that were clear in my head but inaudible cries

to him. It was a moment that felt like forever. I'd survive it but it wouldn't be the last.

Later that night I sat in the rocking chair where I fed our son. I could hear the man who'd held that golf club to my neck, laughing, down the hall. He'd called his mother. He called her every night at first and blamed me, years into our marriage, when that changed. I was a new mother at 19 years old and our son was barely a month at that time. I remember the Winnie the Pooh wall border we'd applied just a month earlier. The streetlights peeked through the blinds and highlighted the yellow and green curtains that matched the Winnie theme. My husband's laughter filled our home as if that earlier moment never happened. The rocker squeaked with each rock, back and forth. We'd bought it for a bargain at a yard sale. It reminded me of one my mother had. It was directly across from my parents' bed in the corner of their bedroom. It was where I'd sit with my mother to watch game shows or reruns of Everybody Loves Raymond. It was the same size and type of wood. The cushion was the same shade of peach with a mix of burgundy. It was ugly. It wasn't appealing to the eyes at all, but it was in our home. The taste of nostalgia made up for its appearance. I sat with the loneliness of that moment as I listened to my husband's laughter. The demon that attacked me earlier felt like it was lifetimes away. I knew if I were to breathe a word of hurt it would *only* be an overreaction to what had happened. It was such a lonely feeling, even while feeding and rocking our newborn. It seemed so lonely. I remember the emptiness in our bed later that night. I remember the helplessness that overcame my bones. I remember fear being the only thing I felt until I could breathe somewhat normally again. I remember my reflection and the marks on my neck. I remember being quiet until I felt accepted by him again. I

remember shushing our son as if we had to honor the silence requested of us. I remember the eggshells. I remember every single eggshell-filled moment. I remember the ghost of the woman I was yesterdays ago. I remember fading, and I remember walking lightly. I still walk that way now so that my existence doesn't take up too much space. I remember 19 years old feeling like a cage, and I remember leaning into his affection anytime he offered the crumbs of it. I remember the uniforms hanging in our closet and how they looked on his body. I remember growing to hate camouflage. I remember pretending to be blind from that moment on, when I knew about his vices. Most of all, I'll never forget the sound of his boots walking away or the door closing and locking when he left for work the following morning. I think back at the irony of those locked doors and how we associate locks to safety. Locks are useless in a burning home. I'll never forget the relief I felt. I'll never forget that it was a Monday morning when the sun came into our bedroom. I watched the dresser's corner waiting for the sun's light to move. I'll never forget the feeling of holding my breath until he was gone. I'll never forget how hard I cried in our bed, when I could finally melt into the emotions I'd numbed the night before. This was the first time I saw the monster in him, but it wouldn't be the last.

silence and worry/ delicately exist/ will everything to be fine/
walk lightly on eggshells/ we know what happened the last
time/ quietly breathe/ submissively do what wives do /ease
egos/ fold laundry/ serve the king his food/ extra thought into
the insecurity of a reflection/ am I pretty enough for affection/ I
don't want to run face to fist after rejection/ how will he react/
watch your tongue/ high school forever/ suffering steals the
young/ easy to say pack up/ leave something violently toxic/
but the outside of the window is a much different view than the
inside of the closet/ everyone talks about the fear/ it's one thing
to hear and judge from far away/ it's another thing to be on the
receiving end of wedding vows before this union of rage/ she
and I/ my sisters who've been here understand leaving and
staying/ gaslit patterns/ gaslit air/ she has a black eye/ everyone
stares more than they care/ brick wall/ face to pavement/ don't
chase those/ say you're sorry/ louder/ we can't place blame
where it goes/ tearful encounter/ situation of unequal power/ I
didn't know then that abuse was all about power and control/
let's talk about it/ the years violence stole/ let's talk about the
cycle/ let's talk about the hold/ breadcrumbs of affection/
honeymoon to tension/ foggy recollection/ fragments of a
woman left/ is it because love makes us whole/ there's an
explosion/ there's screaming/ he still professes his love/ we're
burning here/ I smell death/ let's just clean the bathtub/ why
doesn't she just leave/ well she is disappearing more each day/
nurse the wrong narrative/ blame the victim/ she married him
anyway/ the lord is my witness/ silence the voices/ silence the
thoughts/ delicately exist/ breathe without getting caught/

Imposter Syndrome

The Years in the Fog

Is it visible? I can explain. I've been subtracting moments and there's enough evidence to show the deterioration of this organ we call a heart. Here we are at that second where bleeding red evolves into a numb blue. These colors dissociate too. It's me. Will anyone believe this aching organ that bleeds memories more than it knows to beat? It's me. I am palms full of ice, like time and bruised defeat. Fight, flight, freeze. Isn't life a breeze? It's me. I'm counting pieces of my heart. One by one, I'm giving them a name. There aren't very many that remain. I need to understand this pain. Take inventory, tell me if I'm insane. My eyelids are too heavy to maintain. Is it tears or is it rain? Will anything ever be the same? Boys aren't here to cry wolf. A wolf may not even capture the assassination as heavy as I feel it. Right hand over my chest, is it true that love can steal it?

Boys cry too. We're policing toxic masculinity and every single person who's suffered despite their plea. I'm saying this for them. I'm saying this for me. Thunder like blaring alarms find their way to me, and I follow it in a slowed heartbeat. There it beats—drum, steady alert, hypervigilant form. It's me. The biggest tragedy that's ever been born. Is it rain? The boy isn't crying, or at least not over the storm. The priest says the boy is the wolf. Wolves never learn. The wolf preys on a cradle. Church bells ring. Church foundations burn. The wolf is a failed fable. It's me. I'm losing my religion, can't you see? We packed for crisis and all hands are needed on deck. No one is drowning, or at least not yet.

The ideations are overboard. It's me. I'm in the deep end but the priest won't see. Prayers won't go higher than the ceiling if sin is on your hands. The boy isn't the wolf, and we aren't on land. We may make our way home tonight where midnight finds hindsight to start a fight. We're combative like that. My reflection nods. I think the boy sobs. I'm breaking the mirror because of oppression. Please pay thanks to your god. This is a holy lesson. I've watched from the back row. And I know suicide is a sin. Right hand to my chest, the disciples made their way in. The ideations are on land and they're on the front porch. How dare a woman avoid submission and seek divorce. Women like us lick love off knives. We eat what is served like submissive little wives. The belt is around my neck, and nothing feels fair. I fell asleep again during an obligatory prayer. I want to force myself awake but I'm falling and the man I loved is a shadow beyond my reach. I'm asleep but my ancestors manage to teach all the things these mortal eyes can't see. There's a wolf or a boy and a mess of debris. There's my signature written in ink. Fight. Flight. Freeze.

Waking up is easy to do when the church approves of you, but their promises were burned with the foundation. They won't remember my name or the church I was saved in. The holy boat will sink. Didn't they catch fish? I stumble back to legal ink. I don't remember that last forehead kiss. When I see a shooting star, I'll make a wish. Bartender, please pour another drink. My income decides the fairness I'll receive. You can ask my bank.

I don't know if I should grieve the children or the poverty first. If I am walking ideations, then I wish it ended at birth. Stethoscope crisis. Is this what they mean by *"beating out of my*

chest?" A voice isn't always a choice. I eat more regret. I'm awake and the dream is imagination. I'm awake and the imagination is an ideation. I'm awake and the dream is the truth. I'm awake. It's me. It's you. I'm awake and the church bells summon my selfless acts. I refuse to pray and wait. No one's coming back. Imagine faith on a casket or ruined flowers in Spring. I say that to say, faith doesn't mean anything. The ambulance doesn't show. No one knows I'm hurt. I look at my wounds and use them to measure my worth. The man in the shadow is as real as the darkness, I fear. He whispers lies in my ear. He relishes in every shed tear. He urges me to kill myself. Don't you wish you were somebody else? And then he screams. He slams fist to hand. He demands. There isn't any room to misunderstand. I succumb. I unravel until I'm no boy. I unravel until I'm no wolf. I unravel until I'm undone, and somehow, I'm the monster with a gun and he is the sane one. Don't you see? It's me.

I Swallowed an Ocean in My Dreams Last Night
The Years in the Fog

I'm coming up for air
My lungs have become an ocean
I'm trying and reaching
Coming up for air
I'm gasping and hoping
Coming up for air
I see him in my dreams
I can't escape his stare
I'm running and stumbling
Coming up for air
He didn't push me
He insists I remember this wrong
He follows me from room to room
A predator stalks its prey
I am on the edge of a moment that I don't have words to describe
But in that moment
I'm a mouth covered
I'm a body imprisoned
He'll hold his hand over my mouth and nose
He'll thrust his hips into my body
He laughs as I struggle
I am helpless
My heart tiptoes on dagger blades
It bleeds a begging cry
It pleads for mercy
I'm an inaudible mess
I'm hurting
I'm waking at the end of that moment

I'm a startled nervous system that remembers how hard it was to breathe through moments with a man who was more monster than lover
I see him in my dreams
He follows me into slumber
Room to room
He is closer than my shadow
I feel his breath before he grabs me
Room to room
Until I am cornered and helpless
Room to room
And I have nowhere to go
Room to room
And I still see him in my dreams
Room to room
And I'm an inaudible cry as I sleep
Room to room
I'm fighting ghosts of my past
Room to room
Nobody hears my cries
Room to room
I am blue mercy melting into surrender
Room to room
He finds me in my dreams
Room to room
He reminds me that his initials are embedded in my existence
Wherever I go he will follow
Room to room
My dreams are a prison of bad memories
These recollections mourn and cry
I am running to the other end of my childhood home

It's a mobile home full of stories and excuses that attempt to explain bruises
I fell
It was my brother's toy
I ran into the wall
I don't remember my mother's excuses
She must've had a novel by year twenty
She endured twenty more years of unfortunate imprisonment
My dreams leave me dizzy
I can't walk or run
My legs are knotted
I'm scratching at the floor counting tiles
I'm barely crawling
But I'm moving.
This is impossible entanglement
I am a bewildered and hopeless girl
My face is blurry
These memories are too
He is a giant but I'm over-imagining this again
It's a pattern where I crumble paper and cry from frustration
I use my hands to describe how big these feelings are
I use my hands to describe how tall he is
I use my hands to wave surrender
I'm crumbling paper and waving
I'm in a messy room
I want to leave
Desperate panic finds me in my bedroom corner
Count your fingers
Breathe in deeply
There's a demon sitting on my esophagus
We share a last name

"Baby girl, don't make things up"
Am I running away from a lie
Escape. Escape. Escape.
The door's jammed.
You have to yank harder and harder until it swings open
Ouch
He was lots of feet tall
He yells like thunder that I didn't expect to startle me even
though I've been watching the rain
My past screams out reminders as I sleep
I am an escaping version of my younger self
This is act thirty-one
How many until completion
Hold your hands outward
The weight in your palm is your punishment
The bathroom window is small in an uncertain way
Maybe I'll fit
Maybe I won't
Staring at it is undefined
Trying is the only sure way to know
I try in my dream
I run throughout the trailer park
This is not home
My legs knot before I exit
I can never leave
Is this still a dream
Is this still my life
Is this still a cycle
Am I still asleep
Am I in the ocean

Baby, it's you

The Years in the Fog

i wanted *you*. *i* chose *you*. *i* kept choosing *you* despite the times *you* didn't choose me. *i* wanted *you* despite the times it resulted in injury. *i* wanted *you* despite the times *you* disregarded my safety. *i* wanted your touch even when it was more violence than compassion. *i* wanted your kiss. The love *i* knew in your chaos couldn't speak unless my two lips met your lips for conversations different than the conversations your hands had with my face. But it translated. It always translated, and *i* believed the lies *you* told me. *i* wanted *you* over and painfully over again. *i* wanted *you* over and painfully over again.

what happens when you stop breathing

The Years in the Fog

everything is on fire/
no one is safe/
these walls know more than my neighbor/
he covers my mouth when he's hurting me/
it goes by quickly/
a few seconds without oxygen sends me into panic/
anyone into panic/
but he says i'm overreacting/
i don't actually know how long it lasted/
but i don't want to/
shut up bitch/
it feels urgent and i cry/
something is breaking in me/
i am dizzy with devastation and shock/
the panic is in my stomach/
air is filling my lungs/
i'm going to explode/
shut up bitch/
it feels urgent and i cry/
this moment feels like an eternity/
he laughs/
i've melted into nothing/
i'm under his thumb/
he can let go but even if he doesn't what can i do/
i thought i would die/
i am disappearing/
even if i awake and find that i am still in my body/
i've lost something/

i'm losing pieces of me by the second/
i don't know how to believe this romance anymore/
this has been happening for two years/
i'm so sorry/
i don't know for what/
or to who/
but/
everything is on fire/

Smoke and Mirrors

The Years in the Fog

I'm a walking injury and the reflection that stares back in this mirror isn't me. No one is home. I'm not even home alone. I'm someone in between a life and a dream. The dreamers scream. I am those who dream. When the dream is a nightmare it's honest and I broke every single promise. Fear will find what I left behind. Fear will attach. Fear will make it a point to rewind and remind. Fear will demolish but the crime scene is polished. And the perpetrators are sincere. Even when, they choose which truth to reveal. It's a clear lie but who knows what's real and why. First responders, saviors, and their gods are accomplished. But they're still seeking to imprison the impoverished. They blame the less of these for what's been demolished. Blame the dreamers, it's obvious. Page break and indent a future that proves intent. Bury the truth. Sculpt an appropriate narrative. Dreamers are waking up and they're tired of it. Take a breath, exhale, and reject. My vision is impacted by spinning regret. The children will be home soon. They're only a few blocks away at school. Pulse check, one, two, three, four. I'm a fool. No one is at the door. Pulse check, one, two, three, four. No one comes home anymore. Break the mirrors. Unlock the doors. Unsecure the places that I kept safe before. Here's the bible. Say a prayer. Find a spokesperson. *"Nothing is fair, and it could be worse."* The savior's blessing is the entirety of this curse. Fuck what you heard and listen to what my lips say. This is more than just a bad day. Leave the glass. I need evidence that is gaslight resistance. Eyes on the shattered mess, but they'll still deny and dismiss it.

Don't look at me as if the world sunk you into a place you don't deserve. Your surrender after you've done what you do isn't comforting to me. It's a dangerous dance. Full circle. Round and round again. How can I be convinced when this is our tradition? I can't save you. I've screamed and begged. I sought out a change inside of you. I tried. You broke promises. You broke me and the shattered pieces of my existence still cut me daily. I sought any kind of healing, but I can't find it in this constant state of breaking. My heart is a rattling plea of consistent pain. How am I supposed to find forgiveness if the thing you're sorry for is a thing that still injures me? I fix my lips to grant you forgiveness, but you fix your fists to the same mistake over and over. At what point is this mistake a decision? The ways you break me are repetition. One, two, three, four. One, two, three, four. I don't understand the vows in this war.

Don't look at me as if the world sunk you into a place you don't deserve. Your surrender after you've done what you do isn't comforting to me. It's a dangerous dance. Full circle. Round and round again. How can I be convinced when this is our tradition? We have this dance. We go around in a circle until I fall at your feet, and every inch of your rage releases. You pour hate like poison into flesh. You bruise flesh within the chaos despite the love you profess. You apologize after I meet the floor. You'll apologize and profess it again and again. You spoon feed apologies to me, and I experience the illusion of warmth in your arms. Forehead kiss, bandage, it is proper form. I experience the

illusion of safety in the space around us. Welcome to paradise. Stay awhile. We wrap ourselves into a bond. We wrap ourselves in each other. It adds up into a history. It finds me willing to feel your rage again and again, just to later rest in an illusion of you. The ways you break me are repetition. One, two, three, four. One, two, three, four. I don't understand the vows in this war.

Don't look at me as if the world sunk you into a place you don't deserve. Your surrender after you've done what you do isn't comforting to me. It's a dangerous dance. Full circle. Round and round again. How can I be convinced when this is our tradition? I stumble over fear in my steps. I analyze every word before it leaves my lips to assure it won't interrupt the dream you are. But I am not safe. I am getting warmer and warmer. It is getting too warm. Rage is hot. Rage is red and I do not feel safe. *Help me someone. Help me someone.* But it grows more inaudible until I can't find my own voice anymore. The heat rises. I am not okay. I feel nervous and our tango loses synchronization. We fall? I fall? You push? It happened quickly. I question if it was real or not. Is it even your fault, because I could've fallen over my own two feet. The smallest blind spot justifies your anger. Despite how many bridges you burned to get us here, it's all my fault. Did I really see you push? You couldn't. You wouldn't and if you did it would be a mistake. You pick me up. You collect my pieces and caress where I'm found in duress. You rescue me from the places I ache. You take such good care of me when I'm broken. I'm often wounded open. Hopeless. Once more, we spin into calm. We spin into bliss. I remember this part. Forehead kiss. I stumble out of bed after seasons of this traditional dance we do. My reflection shows the bruises after an afternoon of your rage and evening of your love. I see my reflection covered

in the aftermath and my thoughts bury me with questions. Your apologies find my vulnerabilities and you nurture me back into oblivion. The ways you break me are repetition. One, two, three, four. One, two, three, four. I don't understand the vows in this war.

Who is She

The Years in the Fog

One, two, three, four. I savor every drop of poison he offers. I stumble away with impaired cognitive abilities. He drives my every thought into a direction that benefits him. He drives me into brick walls of self-doubt. He drives me into brick walls of self-hatred. I am wrecked. I digested his lies. I found impairment. Our world became a box that he locked me in. Cup half empty. Isolation further impaired my judgement and in a lens of blurred cognition I only seen him. I made excuses. I stumbled more. He'd hurt me but he'd catch me too. That sufficed. I accepted every blow to my head and stomach. I stayed. Drink up. The bartender doesn't take keys. Drink up. He'd fill my cup up with every act of violence that he called effort. My cup was full of each lie he'd tell, but it never refilled self-worth or anything that would hold me steadily upright. I stayed. I turned each degrading word into song, and then I memorized a chorus. I found flattery because it was written just for me. I held his attention. What a dangerous place to be, but I was his. I was someone if I was his. I drank him up in my cup daily. I filled myself of him so much that eventually I'd lost myself. My reflection was a broken woman, and I didn't know her at all. It's strange how even in my grief for the man he is I still hold myself with more vigilance than I've ever held for him.

If Found, Please Return

The Years in the Fog

I talked to myself, knowing I've already accepted the addiction my heart has devoted itself to. It felt like a war between all the emotions I can't control inside of me and this state of knowingness I had before kissing him back. Sometimes I feel like I lost my mind. The places I'd gone for our love and things I'd accepted felt like happenings out of my control. I started replaying the incidents in my mind wondering which moment I'd lost it; this cognitive presence and ability to see right and wrong. The years blurred and I found myself confused about who I was, what I felt, who he said I was, and what he said I felt. He said these bruises are my fault. If I could've been better, then maybe he could've changed for me. He used the same lips to scream at me. He used the same lips to kiss me. He used the same lips to tell our children goodnight. He used the same lips to tell his mother happy birthday. He used the same lips to call me names. He used the same lips to apologize. He said these bad things are my fault and I've been spinning for years, trying to land on good terms with him for longer than a few days. I've been spinning for years, trying to be better and repair what I've broken. I've been spinning for years, and I couldn't seem to do enough to improve things for long. I know the definition of insanity. I can recite it over and over without doubting its truth, but I can't put this blame down. Maybe the blame is an anchor I keep to maintain some semblance of life. I can't connect myself to her; the girl I was before. Holding this blame is like holding my memory of home. Even in its crumbled mess, I recognize it, but I don't recognize her. I'm scratching to escape these thoughts and the oceans of emotions that inhibit my abilities to

see. I've traveled so long and deserve to have more than fractions of who I used to be. Breathing is hell. Breathing is a chore. Tears pour and pour. I don't know who's keeping score, but what if I'm fighting demons that aren't mine anymore.

The room sat still. I don't recall anything happening as I stirred my coffee face to face with my reality. I've had ten birthdays since I've known him. I've aged and avoided the massive elephant that stomped for my attention. Time flies regardless of permissions given. I'm older and the most consistent memory created over the years has been a feeling of falling. Haven't you had the dream where you're falling? Your heart is in your gut. You're unable to breathe. You can't pause or rescue yourself. You scream. You fear for that moment you hit the ground. You'd anticipate the ground if it took away from the frightening sensation of falling, wouldn't you? If only you had time to think that far ahead. "But why didn't you just leave?" In a decade, that's what I recall- falling. I didn't plan it. I didn't plan a life of erratic emotion. I didn't plan or ask for any of this. I just remember being given a promise ring nearly a decade ago. Late nights we made out for hours in his mom's car. We didn't have excuses for breaking curfew. I hit my big toe on the way inside once. I think it distracted attention away from the time. But even then, it caught up. We got lost in each other on a gazebo in a beach near the Gulf of Mexico. I can still feel the ocean air around us as we dug ourselves deeper into the moment. I sat in his lap engulfed by what I know as so many mistakes now. I couldn't breathe then either. Honestly, I was falling during those times too. How could I forget the feeling? It was falling but also like be carried away. We fell together with little regard to oxygen. We'd get lost and come up for air briefly before getting lost again. It's been hard to understand how the falling wasn't an obvious spiraling. It's been hard to understand the fog. How do

I forgive myself for the fog? In my mid-twenties my life had completely flown by, a sure but slow misery leading up to this moment. This is the beginning of fucking coffee-shop meet and greets. I don't even especially like coffee. But group starts in twenty minutes and that's why I'm here. For the first time in my life, I'm being given the language to understand what happened to me and what happened to my children. Who knew that narcissism was a thing? I didn't. It was hard to process with all the falling. Do you know how long concussions take to heal? How long does it take a black eye to go away? What is a cycle of abuse? Wasn't he just romantic? Sure, flowers can be an appropriate apology. Is that not okay? What is gaslighting? What is all of this material? It was like seeing a book written about what our abusers called romance. "I'm just passionate baby." I'm meeting people who walked away and understand. My reflection isn't something I'm proud of, but I see these women and I'm so damn proud of them. It's teaching me to be proud of myself too, and one day I will be. I just have so many questions to put down and the what if's haunt me. Did you turn off the lights downstairs? I hope I locked the door. I'm doing the best I can with what I have. I'm not a helpless dandelion drifting based on the direction of his breath and the wind anymore. I'm not falling or spiraling. I'm mending and developing the language and support. I'm healing myself and my children, and he gets to walk away from all he's broken. But these beautiful and delightful fucking children can run and laugh as loud as they want to in our new home. Three floors allow them space to exist as they wish. I provided that for them, and at night I'm not lonely. We aren't lonely at night. I'm a little afraid. But otherwise, we're secure, and nobody's falling anymore.

I Can't Connect Months in 2017

The Years in the Fog

Cycles of violence precede my breath.
I hold myself enough for five to cope.
Vases rattle on the kitchen counter,
cruel reality shakes the life out of my hope.
Hazy sadness fills my eyes,
I can barely see signs of any new season.
Despair etched a path across my heart after a grief-stricken
yesterday,
everything happens for a ~~reason.~~
I'm lost inside of what this inherited broken lens for life is,
I can't see beyond shattered families and mistakes.
I wrap a scarf around my neck in the cold of my father's vices,
his steps are like braille encouraging me to heal earthquakes.
I saw the barriers in destruction,
I didn't even need to use my eyes.
My nervous system felt angers corruption second hand,
I knew the truth before ever setting eyes on demise.
I exited the spaces of my closed bedroom door,
tension squeezed my lungs into submission.
I walked lightly, held my breath, and moved quietly;
a hypervigilant body that needs permission.
Old photo books hold onto decades of our family,
I sat under our family tree to pray.
Growing up I spoke our native language following calamity,
I left home early but the roots of where I came from stayed.

The Stranger in Our House

The Years in the Fog

There's an intruder in my home

Unsecured doors are a mistake

I've learned to breathe for five alone

And that blank pages can still ache

There's a stranger in the shadows

The dark feeds evil intentions

I'm a racing heart and doorknob rattled

Shattered glass from the regret of my reflection

There's a silence after impact

And there's blood on the floors

I put a bandage over the aftermath

And no one comes home anymore

Purple Awareness Ribbon

Fast forward to the Repurposed Part

I carry my heart on my sleeve. I tie awareness ribbons there too. I keep extra for me. I keep extra for you. I dig words out of my heart to stitch a dialogue for him. I triage those areas that still hurt and estimate the end. I'm rediscovering the woman I was supposed to be. I'm doing this for her. I'm doing this for me.

Epiphany

The Years in the Fog

ignoring reality hasn't erased the damage of time/ violence throughout the years/ is it my parents demons/ or is it mine/ "quit bringing up" the part that's so uncomfortable to hear/ i've outgrown the versions of me that cater to the demands of fear/ in light of insight my instincts have created a new standard to adhere to/ my ancestors were a lineage of silent strength that violence fed fear to/ there's a roaring in my bloodline/it was waiting to break free/ is it my parents waking up/ or is it just me/

Somewhere in Between

The Years in the Fog

It didn't feel like love, but I remember the keys to our first home. I remember his cammies in the coat closet by the front door and his boots beside the welcome mat. Our bed was an awful shade of red and black. I didn't really like those colors, but I didn't tell him. Dinner was in the oven by 6pm but I think we needed more seasoning on the food. I wasn't his mother. His mother backhand-complimented me over speaker phone, He said it's fine. My neighbor added me on Facebook after weeks of getting to know each other. He bent me over the sink on a Thursday night and I must've screamed too loud because he covered my mouth until I couldn't breathe. He pressed his hand harder and harder until my teeth cut the insides of my mouth and my tongue. I tasted regret for the vows I'd said. I tasted blood. I tasted the woman I never wanted to be. There was carpet burn on my nose from the tussle, but he wasn't even that mad and I overreacted in his narrative. But these words are mine. These experiences are mine. I resent my father. My mother doesn't acknowledge her fear. I silenced my truth. I look like her more as I grow older. My neighbor posted "love shouldn't hurt, you know who you are" on Facebook, and I pretended not to see it. They invited us to dinner. Her husband was a staff sergeant. It didn't feel like love then. We didn't go. I didn't mind because I was running out of happy faces and pleasantries. We canceled for nine months until they moved away. I texted her and said he changed. We reconnected. Hope was rekindled. We visited them on base in their new home. She watched my husband closely. I harbored anxiety when I realized she was assessing his demeanor. I didn't leave him for years, but we stopped talking before I could tell

her that she was right. It didn't feel like love. The crib was assembled across from the rocking chair. The baby slept through the night after three months, and oftentimes I tried not to cry when he hit me because I didn't want to wake our sleeping boy. He didn't worry about that. It was my fault at 2am in July and nearly 4am in August. These months aren't specific but it's impossible to count violence accurately. I don't have a list, but it was a pattern of my own errors. Memory is a funny thing. There are some nights I remember with clarity and others that I lose. There are some buried so deep that even six feet of effort couldn't match those corpses. We drove to find adventures on most weekends and sometimes I'd be silent because I didn't want to start an argument. It wasn't intentional but tension found us, and it was probably something I said or didn't say. He kicked me out of the car in Joshua Tree because he said I was acting different. It was raining. It didn't feel like love. The eggs were scrambled on Saturday morning and the blinds were drawn closed until 12pm. He's in the bathroom on his computer again when I think back to that time. He stayed in there for an hour, and I found him watching porn. He blamed me and called me worthless. I believed him until the age of 26 when my therapist identified this as abuse. It didn't feel like love, but he kissed my forehead before work most mornings. I pretended to be asleep, so I didn't need to face him until later. It didn't feel like love. The holidays were an excuse for a road trip to see our families. We stop for gas too many times to count in Texas and he gave me the silent treatment when I didn't answer his questions fast enough in El Paso. I didn't get out of the car to use the restroom when he pumped gas because I didn't want him to leave me again. It didn't feel like love. We had two children by 2011. Our home was dimly lit by a peppermint candle in December and the

small light above the stove. I remember the air in every corner of our townhome. I remember where the floors creaked and how to sneak out of bed without waking him up. Stealth isn't exactly how you learn to walk as a baby. It's a learned skill in eggshell-like environments. It's a painful lesson. Eggshells were the foundation, and then there are my war wounds. It isn't an easy lesson, but here we are. Tip toe master. It didn't feel like love. There was a hole in the wall where our family picture used to be. His friends thought I was crazy. I screamed too much. We were neighbors. Off-base housing was a small community of proper form. He told so many stories about me. But to be fair, in the beginning of the story he put my head into the wall, and the screaming followed. He left that part out, but I can't, just in case these pages need proof of recollection. He told the church group just enough to get them on his side too. Are there sides in the face of violence because I don't ever recall telling my side of the story until now. I felt problematic and the women at church organized a bible study to talk to me about submitting to my husband. White holy lights and champion Christians knew I wasn't good enough. I believed it. It didn't feel like love. We held hands while driving through Morongo Valley. It still didn't feel like love, but the Marine Corps ball required plans, dressing to the nines, and as little tension as possible. I wore a red dress that complimented his uniform, and I curled my hair to perfection. We danced to a song I don't remember the name of, and I got on my back to keep him happy at a fancy hotel that the military paid for to complete our night. We had four long island iced teas and two is my limit. I was dizzy the next morning. He told me he loved me and rubbed my back. The sex lasted a little over five minutes to my recollection and the room spun the whole time. It didn't feel like love, but my hair fell perfectly in

pictures by the ocean. When he had time off San Diego wasn't that far from the naval base. We would drive down and walk the sand. I remember 68-degree temperatures at 5pm. I remember our hotels and the moments where this was my life, and it was indefinite. It's funny how things change and how quickly we can blink and be in a different life. It didn't feel like love. I wrote him letters I never gave him. I earmarked those pages for a lonely night in my thirties and if he was still beside me, I wonder how much of me would be left. I wonder if I would've ever given him the letters. It didn't feel like love, but we swayed to Toni Tone in the summer. He looked at me with a tenderness that was different from the frequency of angered eyes. Those eyes occurred more often as time went on, but I tried to mentally earmark the circles we danced in too. I didn't want memories like those to get lost in the chaos of his mistakes. He's sorry. It didn't work. It didn't feel like love, but he bought me flowers as apology. My face was blue, but I was rude when I spoke out of turn. Sometimes the flowers talked, and I think the words were something along the lines of persuading forgiveness. They taunted me quite frankly. They told me how to be, and I remember sitting staring out into nothing. Frozen women don't talk back, even to flowers. Women should be quiet and obey their husbands. The flowers were often tulips and the tulips weathered and died in five days. I haven't had tulips since. And maybe five days are too little for something to die but what do I know. I didn't even exist in those spaces. The flowers I encounter are silent now. The days were tense and one week after the first bouquet of the strange tulips, I fell down the stairs because he didn't push me. In fact, I think he tried to catch me. It didn't feel like love, but he brushed loose hair behind my ears and didn't say a word. We communicated with silence

somewhere before the tension. Isn't it a cycle? It was intimate and unsure, or I was unsure. It was turbulent and I guess once the spinning stopped the silence confused me, but I even knew then that silence wasn't peace. It was blue and I was sad. He was sorry. He was sorry again and again. On a Monday night he came home from work upset. I checked the time on his phone while we were reheating dinner and he shoved me into the counters corner. It left a mark, but he didn't even push me that hard. I should have been more careful. It didn't feel like love. He put a password on his phone. He never looked at mine, or at least that's what he said, but he frequently checked more than the time on my phone. He had to. He accused me of cheating, frequently. It didn't feel like love, but we stayed married for almost 7 years until we separated. The divorce finalized before the ten-year mark, and he didn't make eye contact at the last court hearing. I wore heels and tried not to appear too frazzled. I brought a victim advocate, and she held my hand when he walked past me. It didn't feel like love, and I fought in court for two and a half years attempting to untangle all the years of family, violence, and whatever else was in between. In the first months of court sessions, I saw him at a crosswalk. It was 8am and unexpected. He stared at me with some kind of evil, but even the devil's eyes are kinder. I pretended not to see him. I was glad that I wore sunglasses. It didn't feel like love, but we had four children. My daughters asked about their dad. My three-year-old said that daddy turned into a monster. I was speechless and I kissed her forehead, as if I could kiss it better, but I knew she experienced a version of hell in the home we had with him. She looked at me with love, but I feel that I let them all down. It didn't feel like love, and I don't feel like myself anymore. I lost the woman I wanted to be in the divorce and too many other legal documents

that altered our life path. It didn't feel like love, and I reconnected with the neighbor who knew about the secrets in our home before I was able to identify them. I filled her in, and we talked for hours. She was glad that I left, but we both acknowledged the error in how long it took me to leave him.

Picture This
The Years in the Fog

I can't say once upon a time without saying rest in peace to all that was. The beginning is far away from the ending, even though chaos and apologies blurred the lines. Years of turbulence landed us on the last breath where we died. Here's a visual, the love of my life destroyed me, a garden of roses trampled through, smashed roses, shattered vows. and flattened zest. Where is the fervor? Here's to a hypervigilant spring. Visual, girl on her knees, there's a broken vase, and glass cuts her skin. She so desperately wants to piece this vase back together. Don't forget that I am she. Don't forget that I am her. The vase represents her family, it's a gift from her grandmother, it's pieces of her past that she wants back, it's pieces of her story she wants to understand, it's versions of herself that made her whole, it's everything that's ever shattered and left her buried in regret, and it's a damaged family lineage. Visual, broken mirrors, I don't see myself clearly, I am a distorted reflection of myself, I don't know when these cracks happened, shattered, and tainted time tell a story. Do I even know it? My reflection looks back at me. There's one eye separate from my face. It dangles into the nothingness of a kind of silence I don't know how to describe. This version of me doesn't make sense. Visual, empty arms, the labor and delivery nurse takes the baby, picture an empty house and silent rooms, her stomach will lose its pregnancy weight, but her existence will never lose the grief. Visual, eulogy written too soon, apologies to all my friends and family, tombstone, audacity, despair, and goodbye. Visual, tug a war competition, court hearings, harassment, push and pull, run and return, face him, look at him but not in his eyes. Fix your

eyes in a way that can see him without needing to look up, a sideway glance. I don't know what I expected to see but it didn't make me feel good. I was afraid, curious enough, confused and I eventually looked away. I waited on my attorney's cues. The rope grew heavy. The weight on the other end of it feels larger than what I could fight. I sweat, tried. The protective order was granted. Visual, wall of Jericho, imagine midnight, doors banged on, protective order violated, you are my sunshine, drive away, drive so far away, fight, flight, or freeze until I remembered how to breathe. Visual, airplanes on the tarmac and thirty thousand feet into the air. I was reacting. I'm not me when I'm afraid. Visual, he wasn't the love of my life, a bouquet of plastic roses, take care of them, but those roses aren't real. Manipulation and deceit. And it was misleading long enough to be a decade long marriage.

We Can't Blame the Alcohol
I had a Concussion, and I Don't Remember the Details

He swallows his alcohol before the regret, but sometimes I'm not sure if regret exists in the apology, or if the apology is the bondage. At times it seems like glue to hold me close enough so that I don't leave, but I'm far enough to be aware of the wound growing between us. It's an injured sort of thing. My blood is all over it and sometimes his reflection seems stained on the surface, but in other times I'm not sure if any of this is his fault. Haven't you heard that she fell down the stairs? Don't you know that she bruises easily? We don't know where the blood came from, and the windows? They were cheap. It seems like a landlord issue. Don't you know how they cut corners to save money? We can put these lies in a frame, and so we do. We did. I did. He didn't hold a gun to my head. Yes, his love is at my throat. Yes, his love is violence. Yes, it is deceptive that way, but he didn't hold a gun. He didn't force me to frame anything. The family picture is broken, and the lies are getting colder from exposure.

The Water is All the Way Off

The Years in the Fog

I don't know how it happened but somehow, I'm the violence and the victim. Somehow, I'm raging red and aching blue. Somehow, I'm less of me and more of you. "Daddy turned into a monster." Turn the faucet all the way off. In silence the leak gives us comfort. In silence I get lost. You wrapped your hands around my throat. Petechiae reveals the truth. Your lips are so unholy. It's because they belong to you. You have coffee with satan. I don't know what you say. The violence is such an intrusion. This space isn't safe. The faucet leak becomes a soundtrack. I feel the heat of hell. I move carefully so they don't crack. Damn these eggshells. He's a shattered mistake. There is no putting it back together. Once the flood gets to the moving boxes, we can't undo bad weather. You're more violence than love. Be quiet for the faceless man. There's broken glass he won't sweep up. I'm the only one who can. I put my hand over my reflection in the mirror. My heart still beats in my chest. I stare at fragments of who I am, but she's all I have left.

Dark Infinity

The Years in the Fog

Love spun my head into circles/ dizziness and oblivious everyday/ the butterflies he gave could've actually carried me away/ maybe they did/ drifting was a consistent memory/ drifting/ more like falling into the depths of a repetitive infinity/ my face/ it hurt/ but it was just one time/ make up sex/lie within a rhythm/ conditioned my mind/ he whispered/ he rescued me from his darkness/ I tried to wish away the places in his heart that were hardened/ I can fix him/ he'll change/ he loves me to the moon/ evil is such a conviction/ constant friction/ his arms were my doom/ my face/ my reflection/ it doesn't look so nice/ but it's okay/ it's alright/ it only happened twice/ and then/ three/ four/ five/ six/ seven/ sometimes I'm burned by the fire of his rage/ but sometimes he's my heaven/ and then eight/ nine/ and nine times nine/ but really I'm fine/ because that was the last time/ and he's going to change anyway/ so I don't walk away/ I stay/ but who can really walk away from someone they love this way/ but if he does it again I swear to god I'll go/ and don't look at me like that because you don't really know until you know/ and I hope you never have to decide when to stay and when to go/ because when is it ever really a good time to go?

Someplace Long Ago...

The Years in the Fog

Nights under the stars and kissing in your car.
In your arms I melted so quickly.
Immediately, like liquor shots, deception hit me.
I picked up pieces of you along the way.
I was invincible, so full of principle, and nothing could hold
me down.
Oh, you enticed me, and at times nightly, but you knew how to
bring me down.
I carried the pieces of you that I collected.
Where did it begin?
Where did that principle bend?
Where did you begin?
Where did I end?
You sold me your feelings and told me they were mine, but it
was fine.

I carried pieces of you that I collected.

And even if I was neglected, I couldn't help it.

You were now my life.

And it was always strife, heart to knife.

I was so blind.

You blurred the lines.

I wasn't fine.

I couldn't even find the parts of myself that were supposed to be mine.

I lost all of my pieces.

And I cut myself on shattered mess, doing my best, only to accept that she was already gone.

The windows are broken, I left my heart open.

That house wasn't a home.

For My Sisters

We're More Than the Cycles That Precede Us

Our direction for life started as a crooked wheel. I can't assume but I feel that pride was how we'd deal. Without knowing any other armor, pride can keep us safe. I can't speak for you, but that's at least my take. I, myself, I flailed until I knew how to walk and even today, I still find myself trying to breathe without getting caught. Love catches me gasping back the guilt of all this distance. The earthquakes I heal tussle with self-preservation and that's been my resistance. My reflection tells me to remember that you're fighting too. In the deep of my own ocean, I save room in this boat for you. In my silence, I've scratched and felt my way back to the woman I want to be. The speed bumps and the mountains, they've each been like brail to me. Time is the most valuable thing we have, and I needed solitude in that until I felt okay. In the burning houses we inherit, I find gratitude that neither of us stayed. For my sisters, listen, I want you to know that I see you. There's no time or distance that could persuade me to leave you. This silence is about the peace I wanted to pave a path for. In the midnight hour I remember what we're fighting for. Our ancestors know more about us than we know of ourselves. The wisdom is an umbrella that we can't see on our way back from hell. In the fingerprint of our choices, we hold the pain I wouldn't wish on anyone. At no point during these fires can we say our healing is done. As exhausting as it's been I hope it continues to lead to a better life. May we heal ourselves and our children and never again lick love off knives. I've come to understand that some violence is a grey area, and this makes it legal. The voices raised and tension found; hell has less upheaval. Biology taught us what we carried away from our childhood home about love. I'm sitting here with thirty-two years where I haven't received

enough hugs. This may sound adolescent, but I needed more than what we were given. What we left home with was a mirror to what we'd give our children. In the fog of my past, I hold a rose to the flames of what was. The rose is hope for better and an abundance of love. Yesterday doesn't define who we're destined to be. I've also learned that the second greatest thing I've ever been is free. I put off writing this because I wasn't sure that I had the words, but the truth is that I was building up the courage to dissect our history and face every terrible thing. But I've shoveled through the dirt of false worth and I've found our wings.

I love you, keep going.

A Note for Later

A Date in the Future

At times I'll be exposed to people who aren't my people. I've
been hurt by the weight of judgment in places that only
compassion could comprehend. It hurt to let the wrong people
in. This life is full of mistakes. The wrong people will dig up
more doubt than acceptance. I can't control or change that. My
mental health has been in a much safer place since I've decided
that I define who I am. It's gotten easier to move forward when
I put down all the things that don't belong to me. I refuse to
argue about who I am with people who seek to discredit me
and misunderstand me. I don't find malice in these words. I
find my healing language in the transparency of learning
myself and learning to carry my past strategically and gently.
Transparency has been a gift. It helps eliminate those that
aren't really for me and discern who is. Those who are for me
stay. Transparency isn't a bad thing. Although, self-disclosure
can be dangerous in the wrong hands. There has to be a certain
strategy that requires adaption to environments. But even as
life progresses, I expect to repeat mistakes and stumble, and in
that I have to forgive myself. I will remember who I am despite
any cloud handed to me. I will remember who I am in this
human experience. Sure, I go back and forth in my head. Sure,
I have moments where I'm not very nice to myself, but we all
have internal battles. But my mental health has had much more
clarity since I've put down the doubt of others and their
opinions. My mental health has had much more space for the
grace I need to give myself to be where and how I need to be
now. I deserve freedom from the opinions about my story. I
deserve to be heard and understood. And to go a bit further, I

deserve unconditional love. It hurts when people leave. Rejection is such a heart piercing reality to grasp. But when people leave because of my mental health and/or trauma I find freedom. It hurts but it doesn't hurt as much as the bondage of people pleasing. When people decide they need to exit it's best to let them exit. I'll meet people who have good intentions but find themselves off track with me. Relationships tend to buckle under expectations. It's common for support systems to get overwhelmed when their expectations aren't met. It's common to feel frustrated or disappointed when things seemed okay, but I'm found stumbling into a bad day. I'm personally okay with my bad days now, but I've had friends grow tired of the ups and downs. I understand the good intentions and I can even understand the overwhelmed and frustrated place. However, my mental health journey is individual to me. I had to be okay with people choosing to walk away and learn to sit with myself. It hurts to feel misunderstood and rejected but I can't control other people's actions. I can only choose how I react. My energy is mine and I had to learn to choose my battles, so I don't fight for people to stay. I need to fight for myself. I need to fight for me to stay. Choose you.

The Company We Keep

The Year of the Fog

Healthy interpersonal relationships are an important piece of mental and emotional wellness. When our environments are withering, we're impacted as well. This affects our wellness. The relationships we have with others can either support or deteriorate our mental, emotional, and spiritual state. We are also singularly important. The relationship we have with ourselves is crucial to self-regulate ourselves to create and maintain healthy boundaries in relationships. Our intrapersonal skills are the internal abilities and behaviors that help manage emotions, cope with challenges, and learn new information. These skills, which relate to emotional intelligence, include things like self-confidence, resilience. I encourage you to consider where you are planted and your surroundings. I encourage you to monitor that internal voice and look at your relationships with yourself and others. When we are aware, healthy within, and consistent with our boundaries we cultivate healthy places within and around us. Room check, who's in yours?

Here is a list of things I learned so far

- Violence is a choice. It's about power and control.

- The accountability belongs to the perpetrator and the perpetrator only.

- Victim blaming doesn't change the truth just because the narrative is being manipulated.

- As a survivor I know how hard it is to see what's happening when you're inside of it. It's seven years later and I see red flags clearer now.

- If you're new to this end of things, please know that it isn't your fault. There's nothing you could've done or said that meant you deserved abuse.

- There is never an excuse for abuse. We can find reasons and dissect patterns but none of these are excuses.

- I come from cycles of violence, and I have siblings who chose not to abuse their partners.

- It isn't anyone else's responsibility to help a perpetrator change or heal.

- A boundary isn't a suggestion. It isn't a challenge. It shouldn't be taken as a personal offense, and if anyone has ever made you feel bad about setting a boundary that's a red flag too.

- Abusers are charming. They know how to charm people and adapt to social/public situations accordingly. This is further proof that the abuse is a choice.

- The passion found in make-up sex is a lie. It can feel like a bondage because it's translated as love when it really isn't love. Love shouldn't hurt.

- Isolation is dangerous.

- Autonomy is important to maintain in a healthy relationship.

- Relationships are about coming together and solving any issues that arise as a team. Conflict does happen and can be solved in healthy and safe environments.

- Fight, flight, freeze, and even fawn are common for years post-abusive relationships or any other trauma.

- I didn't understand love for years after, until I lived in a safe home environment with unconditional love present.

- You are allowed to learn new things and ways to be who you desire to be.

- You are allowed to feel your feelings and space to share these. Voicing your feelings shouldn't turn into an argument.

- You are allowed to have your own love language.

- You are allowed to grow and to not have all of the answers.

There are serious factors that weigh on the survivor's decision to leave:

As noted by *Women Against Abuse*, leaving can be dangerous: Many people experiencing intimate partner violence, realistically fear that their abusive partner's actions will become more violent and even lethal if they attempt to leave. The abuser may have threatened to kill them or hurt their child, family member or pet if they leave.

Many survivors are not sure that leaving would be the best for their children (especially if the children are not being abused directly.)

Concerns may include:

- *Will my partner win custody of the children?*
- *How will I support my kids without my partner's income?*
- *I want my children to have two parents.*

The survivor's friends and family may not know about the abuse or may not support their leaving; or the survivor may have no one to turn to, since isolation is a key dynamic of intimate partner violence.

Most abusive partners exhibit a behavioral pattern that has been described as a cycle of violence.

The cycle of violence has three phases:

- the honeymoon phase (when everything in the relationship seems lovely)
- tension building (eggshell feeling)
- violent incident

Many abusive partners become remorseful after inflicting violence and promise that they will change (beginning the honeymoon phase again).

This cycle makes it difficult to break free from an abusive partner.

The survivor may not have their own source of income due to financial abuse, or may not have access to alternate housing, cash, or bank accounts.

Institutional Responses:

- Clergy and secular counselors are often trained to see only the goal of "saving" the marriage at all costs, rather than the goal of stopping the violence.

- Police officers do not consistently provide support to survivors. They may treat violence as a "domestic dispute," instead of a crime where one person is attacking another person. Despite the issuing of a restraining order, there is little to prevent a released abusive partner from returning and repeating the assault. A city's lack of affordable safe housing and limited number of emergency shelter beds for survivors of domestic violence may mean there is no place to go.

- Social Barriers: Some survivors may not believe divorce is a viable alternative. Some survivors are socialized to believe that they are responsible for making their marriage work, or for keeping the family together. In some cultures, leaving your partner is a disgraceful and reprehensible action.

- Having disability: A person with a physical disability is five times more likely than a person without a disability to be abused by a partner, spouse or someone considered to be part of their household. Belonging to a sexual minority. Learn more about intimate partner violence in LGBTQ+ relationships.

Hous·ing

A study of 3,400 shelter residents in domestic violence programs across eight states found that housing is one of the main needs identified by survivors at the time of shelter entry. 84% of participants reported that they needed help with finding affordable housing.

Survivors have reported that if a domestic violence shelter did not exist, the consequences for them would be dire: homelessness, serious losses including loss of their children, actions taken in desperations, or continued abuse/death.

According to multiple studies examining the causes of homelessness among mothers with children, more than 80% had previously experienced domestic violence.

Between 22 and 57% of all homeless women report that domestic violence was the immediate cause of their homelessness.

Is This Thing On

The Homeless Chronicles

I don't have an unpopular opinion for you unless we agree to deny the reality of factual evidence. But we aren't here for that. We're here because I have something to say, and as fleeting as time feels, this reality hasn't escaped me. I remember when I wake up. I think about it during commutes. I think about it in the shower. I even think about it while trying not to think about it. It consumes every second of my day. It's always on the edge of my tongue and in the corners of my mind. I've gotten lost in the dizziness of how quickly it happened, and the fog of grief that has since consumed me. And I'm not saying you should think about it like I do, but can we sit with it? Can we say the word, homelessness, homelessness, homelessness?

I can't sound off alarms or scream it from wherever I'd be heard. And from the outside looking in, it's hard to see. I'm here to be your eyes. I'm hoping that you see it, really look at it, and fully see it. There are so many members of our communities and citizens of this cruel world that need you to see. We can't talk about the issues without the impact. I can't give you statistics without showing you where it hurts, and I don't want you to exit this space without fully understanding the magnitude of homelessness, each issue that leads to it, and the issues compounded within it that create chronic homelessness.

"We don't have room for families of five."

1. TESSA
2. Partners in Housing
3. Catholic Charities
4. Family Promise
5. Section 8 waitlist
6. Dream Center/ Mary's Home
7. Interfaith Hospitality Network
8. Colorado House Resource Center
9. Rescue Mission
10. The Salvation Army*

Tell me where's your god. Tell me how righteous one needs to be for mercy. The year is 2016. I remember the snow and the footprints that were in it. The moon felt different then, like an existence my questions circled around. The prayers dissipated. The sky didn't have space to keep them. The sky, a tunnel for miracles. Other prayers must be well on their way to solutions and the kind of compassion it takes to receive mercy. Every pew had a different opportunity for congregational community. Oh, I sat. Oh, I cried. Oh, I kneeled into a submission I believed worthy, but my worth didn't meet the worth needed for good disciples.

January, the volunteer work will add to my resume. I have court before volunteer hours. I am a temple of woman. I'm building a structure from the ashes of a former foundation. When you're divorced, you're second hand in man's eyes. I, a thrift store of a woman, will be celibate until a new husband chooses me. We arrived in Colorado Springs as a family of six. Summer of 2015. We crumbled from the violence that always existed in our family unit.

I knew we needed help. As a single mother four, I reached, I surrendered, I sought, I unveiled, I pleaded, I got whatever refuge was needed to be okay. We needed to be okay. The court hearings will proceed, and words aren't enough emphasis on how long they'll be a storm cloud in our lives for.

Do you know how hard it is to get a permanent restraining order? Very.

January, the restraining order was made permanent.

February, what a busy blur. Can you imagine a single mother who survived violence rebuilding a life? Before I provoked this thought was it even a wonder in your mind?

March, the garage door is broken. The police take an hour to arrive. The air is cold. Without a garage door that closes functionally we were exposed. VAWA exists for situations like this. What is VAWA? Important. We needed to find someplace new.

Trust, Education, Safety, Support and Action. TESSA has a safe house. There's no room for a family of five. The only domestic violence services were provided by TESSA. We will remain in our first home until November of 2016. We will try to find different programs to house us and support our family before the temporary two-year voucher expires. On top of safety, basic needs are another cloud over our heads. Back up, TESSA didn't have room for a family of five when our garage door was broken and we were being harassed.

A partner in housing isn't what we had. April, rejection isn't a surprise. We went to Partner's in Housing for their housing program. I volunteered there in the donations part too. I networked. I pushed. But the results were still a no.

May, the voucher is good, but the credit isn't. There's a stigma with section 8. By the time I find a safe place to move with the help of VAWA, the two-year voucher will be up anyhow.

Back up, January, the restraining order and police reports are used to get our perpetrator's veteran housing benefits. It is two years. It is split in half, same number of years, different places. Time was fleeting.

June, what a busy blur. How many therapy sessions will it take to understand? Peel the skin until the bones are tangible. July, we are hot, but we are happy. We are trying to feel safe, but we are still happy. The search for safe housing continues. Nighttime is the worst. The couch is in front of the main entrance to our house. The table is in front of the garage entrance. The children are asleep. This reality is under the rug in our living room by morning. Pancakes will be ready and waiting on the table that's centered again.

I was diagnosed with post-traumatic stress disorder, but I wonder why. I don't. I really don't wonder because I know, and PTSD feels so singular when compared to the period of time where trauma was prolonged. Where are we?

June, the children are deep in therapy. I was hired at the agency and all I can say is that, sometimes, women don't believe other women when their men are involved. But the therapy for the children is progressing, and this otherwise doesn't end well. It is downhill after a man I barely knew did a thing I won't say. I don't know how I feel about an opening for translation but sometimes the truth is a manipulated narrative that carries more weight than the witness can anyway. Can an entire organization discredit a person based on history, trauma, and naivety? I don't know. Can an entire church solidify a woman as unclean even if the lord says thy will is being done? Where will Mary give birth? There isn't room. There's simply no room.

August, September, October, these are understandably cloudy. Things at work are trying after the sexual harassment incident. This job was crucial to the rebuilding of our lives. This place was also crucial for the therapy that the blurred boundaries will impede on.

November, one week in one church after another. This is a transition to housing. We are bending the rules. It won't last. This charity is running low. The pastor won't use the tithe to contribute. His car is so nice. At 6am families wake up and shower. There's a system. Please stay in line according to admission rules. Where did Mary go to give birth? Did the animals symbolize her status according to the inns? The church says come as you are, but can we clarify who they let in? The bandage isn't a fix. What about longevity in a unit post transition? You're only allowed two people per room per housing subsidy guidelines and the housing voucher can only afford a two bedroom. There isn't a loophole. Where will I put my baby?

There's barely a year left, and I couldn't find another program to help with housing post voucher. How will we continue healing? Was Mary judged by the community she lived in? Is this what the sanctity of the cross requires when a woman is so desperately in need? How far should I have scratched to make ends meet? Should I have accepted the toxic man's offer in 2016? He had money, and though red flags cautioned me, he could've helped. But we all know how cycles work and there are some walls I put up after my ex that I refused to take down. We are struggling but we are safe.

Family Promise is but a dream, but a family of five isn't supported here either. We don't have the resources. There's a waitlist for a housing voucher after the veteran voucher expires. You *can* move under VAWA (Violence Against Women's Act), but you aren't guaranteed a place. We are nearly a year into the voucher and although we exited our first home that we obtained using the veteran voucher VAWA isn't helping with shelter. We

are floating about. We are ghosts in society. Safety came with a price. Mary's said righteousness came with a price too, but can the church recognize the holes in its sanctity. We live in a society that has systems that facilitate their own agendas creating biases for who they serve. Wasn't Dream Center a survivor centered safe-haven?

Oh, I sat. Oh, I cried. Oh, I surrendered. Oh, I kneeled. I waited to talk to a higher authority that also reviewed our family application and said no. There are one too many of you. Their mission statement contradicted loudly in the corners of my mind as I held onto last strands of hope. What does the innkeeper say about this generosity that supposedly existed in Bethlehem? There wasn't even room for the son of god himself. Is it revelation or pattern that the same revered followers of christ couldn't make room for a woman and her four children when the plea is stretched out by the savior's feet and they're begging to be saved?

Violence Against Women Act

The Violence Against Women Act of 1994 is a United States federal law signed by President Bill Clinton on September 13, 1994

In recognition of the severity of the crimes associated with domestic violence, sexual assault and stalking, Congress passed the Violence Against Women Act of 1994 (VAWA 1994) as part of the Violent Crime Control and Law Enforcement Act of 1994. The protections and provisions afforded by the 1994 legislation were subsequently expanded and improved in the Violence Against Women Act of 2000 (VAWA 2000) and the Violence Against Women and Department of Justice Reauthorization Act of 2005 (VAWA 2005).

The 1994 bill was a watershed, marking the first comprehensive federal legislative package designed to end violence against women. It was also a triumph for women's groups that lobbied hard to persuade Congress to legislate federal protections for women on the grounds that states were failing in their efforts to address this violence. VAWA included provisions on rape and battering that focused on prevention, funding for victim services and evidentiary matters. It included the first federal criminal law against battering and a requirement that every state afford full faith and credit to orders of protection issued anywhere in the United States. Since the passage of VAWA, from law enforcement to victim services to Capitol Hill, there has been a paradigm shift in how the issue of violence against women is addressed.

The enactment of VAWA 1994 culminated an effort begun in 1990 to draft and pass what became this landmark legislation.

President Joseph Biden, then Senator from Delaware, initiated this effort when he submitted to Congress a preliminary proposal to address the issue of violence against women, sparking a long-awaited national conversation about violence prevention and services. Working closely with the staff of the Senate Judiciary Committee, Legal Momentum (then NOW Legal Defense and Education Fund) brought experts and organizations together in the Task Force on the Violence Against Women Act to help draft and pass the legislation. This initial coalition has become the very large and diverse National Task Force to End Sexual and Domestic Violence, which continues to collaborate to help draft and pass each VAWA reauthorization.

This Thing Still Isn't On

The Homeless Chronicles

My world is on fire, this little world of isolation and despair. I can't breathe through the suffocation of reality. I can't breathe through this air. Life only has one certainty, completion. When have I ever finished anything? I have too many reasons to reach out to these demons. Daylight peaks over the liquor store sign. I blink. I'm unsure. Am I barely awake or barely alive? There are so many nights where I've died. Are the stars eulogies or delusions? Can a girl wish? I'm barely awake. I'm barely alive. I can't live like this. Existence is heavy. I'm full of disappointment. I'm full of stories. I'm full of losses. I'm full of tales. I'm full of terror. I'm full of dreams. I'm full of error. Take me anyplace other than here. I am afraid. I'm full of fear. I feel my spirit begging to be free and my flesh is a prison. I want to crawl out of it. No one listens.

Solitude has an Unusual Price

The Homeless Chronicles

There's something about waking up in parking lots that stole the light out of my spirit. I slept where beds weren't meant to be. Hypervigilance keeps an eye open. People who peered into my windows watched me sleep. I gambled with insanity. I cried the loudest cry and held myself tightly. I lived the biggest lie and crumbled in my dark reality nightly. There's something about waking up in parking lots that beat me lower than I've ever been. There was a tearing of my heart, and every attempted triage was an unsuccessful mend. There's something earth shattering about waking up in parking lots that leaves me without a light to believe in. In emptiness I rock myself to sleep with no more of an expectation than to grieve again. But there's something about waking up in parking lots that gave me moments where it was good to be alone. There's something about waking up in parking lots that was still better than my childhood home.

Did you Tithe Sunday?

The Homeless Chronicles

Today is Sunday and I'm found again at the altar of despair. The pain is unreal here. It isn't imaginary. Hope can't carry me. It exists and it's alive in the veins throughout a body that I hate. The person I am, I can't change her. It's much too late. The pain is alive here and it beats me down in every heartbeat that unfortunately continues to sustain my existence. No one is restraining me anymore, it's my own resistance. I exist here at this altar of despair. The pain is unusual here. Today the pastor at your church will probably talk about miracles. But my water is never wine and when I'm sipping anything it's from a half empty cup. Tomorrow isn't certain and there's never enough. I'm an empty space. I know too many things about breaking. The choir will probably echo hallelujah again and ignore my aching. Tithing is your rescue boat or that's at least what they want us to believe. I've got twenty dollars. Teach me how to grieve. My music has become shattering. It's the only sound I can hear, and it may not be music to you but it's music to me here. At this altar of despair, I wonder if anyone will remember my name. It must be hard to associate me to anything other than shame. I am not healed. I am broken. I'm eternally shattered, and I can't make sense of the pieces that used to be me. Welcome to the altar of despair. This isn't anything other than another tragedy to see.

8960 Knott Avenue

The Homeless Chronicles

Months ago, I placed a brick on a lonely and beaten concrete
foundation.
I stared at it knowing that despite how long it took,
I'd find a way to create something bigger than the silence of
isolation.

I learned how to let go of the walls.
I learned that you don't really know love until you're hanging
onto something you're afraid to lose.
I learned to place words where life once had a place and a face
to come home to.

There is a final breath of goodbye.

I found so many ways to say advocate
and hundreds more to say
"I'm sorry."
The variety of twenty-six letters shaped homes for heavy
feelings
and bridges into a lifetime long apology.

I picked up the therapy of language and
I learned that some words require a warning before impact.
I learned to count to four a thousand times
and bleed regret before ever bandaging the aftermath.

There is a final breath of goodbye.

I stitched stanzas of suicidality into art.
I learned how to answer that burning question from therapy,
"How does that make you feel?"
The pages I've cried on became a masterpiece
of broken parts
and I learned that we need scars to prove the past was real.

I've learned that five minus four is one
And one can be multiplied by grief in infinite numbers.
I've learned to remember my umbrella
but I'm still learning to embrace my thunder.

There is a final breath of goodbye.

I've learned that some eyes only exist for rainbows
and other eyes don't mind the hidden items from the dark corner
of my closet.
I've learned that over time sadness can flood a place meant to be
home
all because of the harmless drip we ignore from the kitchen
faucet.

I've learned that violence is red,
and I can still breathe while being too many shades of blue.
I've gone back into my childhood home
and returned the notion that I should only speak when I'm spoken
to.

There is a final breath of goodbye.

I've learned that intoxication has more syllables than bereavement
and demise can happen with one blink of an eye.

I've learned how to shape a stanza after breakdowns during midnight
and that I can continue breathing long after I feel I've died.

I've learned how to keep shame in my pocket unless I'm fitting it into a run on sentence
and choking on every second where it's exposed to other eyes.
I've beaten the repetition of this strange life into the hearts willing to listen
and found triage within lines of poetry when I've felt the least alive.

There is a final breath of goodbye.

I've learned how to fit a lifetime of heartbreak into the formation of too many words that flow rhythm despite ache.
I've learned how to empty the fullness of a family's heart and silently turn blue from legal ink.

I've learned the discomfort of melancholy when the choir only wishes to sing a worship song.
Yet, I know that an expectation of silence after violence still means someone's doing it all wrong.

There is a final breath of goodbye.

I Still Remember the Smell of Dorm B

The Homeless Chronicles

The things that keep me up at night howl deep in my bones; a wolf on a mountain talking to the moon. They're a hurricane on land. They carry the repetition of a wave hitting the shore over and over. My chest caves in, leaving me under the weight of a boulder. My name on that signature line, I'm not me when I'm desperate. I want to erase it. It twists me into spinning regret and the thought stomps for my undivided attention tonight in the darkness that's consuming me. I keep the name tags from my old roles. I'm an advocate now. I've been a case manager. I've been too many titles these days. My reflection reminds me not to sink into submission. I'm a "Ms." now. It's been almost five years since my divorce. The final court hearing was barely twenty minutes. The chains were tightened for a two-year period. I signed those papers too. Keep the spinning regret, I have relief. But freedom found me on the edge of a question. What do you do with it? I shaped a tool from the scraps of an old life. I can't grasp the ones I want from that chapter. Little laughs echo in my dreams. I'm not new to mental health. I'm not new to crisis. There's a fire about my existence that keeps me in four walls I can't escape. I understand the trees and how they stand despite the weather and exist one season at a time even when it's in the same week. In my dreams I'm back at the shelter. It isn't the bunk bed from 2018, the one I think about when I think of my training for Disneyland and streetlights after work. In 2018 I went back to the heaviest bunk bed that exists. Bridges and Kramer, three years later I receive referrals as a case manager from Bridges. This misery didn't begin with me, and it definitely doesn't end with me. At bridges and Kramer, I fell asleep on a

toilet. Never did I ever think I'd see a day where I felt that low. How could I anticipate it? It all happened so quickly. Cannon ball into a wall. Shooting star into the distance. Explosion after the pin drops. Quickness. The 9pm fireworks left me on the edge of reality's poverty. My reflection, "this is my life. " Wake up, fight, sleep, repeat. I checked in with a guard who checked my bags before returning to my bunk, but he didn't need to take inventory. Everything he needed to know was already written on my face. But these dreams bring me to the shelter from 2021 where I'm a case manager holding deja vu. I'm more gentle with others than I am with myself. My tone doesn't change. "Can you try to take a deep breath?" My mind was deep in the lives of those I seen Planet Fitness parking lot relations in. "It's so hard, I'm so sorry." I slept on a temporary situation. Nine hundred dollars was the cheapest by the ocean. I walk the pier. It wasn't intentional. I stumble into roommates and cry into the midnight hour. "It hurts, doesn't it?" No one can afford to breathe in California, no one I know. My caseload grew. I couldn't put the files down off the clock. I wish I could fix every system that fails us. I know there's a chance we won't be okay. Hope isn't in my pocket anymore and I notice the clock at 3:33pm with wonder. This can't be the right road. I don't know where this road goes. If we exit with any luck, we can have basic needs met, but this life isn't meant to just survive. I sit in my car for hours idle in common moments. I remember these minutes and how slow the damage buries you. Still, every night hell is at my car window. My stomach rumbles. I am employed. I am an empty gas tank until Friday. I am please make it. I was anyway. I did rounds at the shelter. Dorm to dorm every hour. I've never seen meth before then. I'd never slid under bathroom doors to triage an overdose. She was sadness in a mistake. I'd never seen a person

bleeding out on the floor either. I didn't see him in time. He was too heavy to turn over to his side. The paramedics called time of death once they arrived. There was a tunnel in my exit that night. I don't know where to put this grief. It followed me into each chapter like the ghost I can't identify in the corner of new moments. We couldn't inform his family. Where is a person who experiences homelessness going to call home? Who will go searching for the lost ones? Lifelines fail. Emergency contacts are blank. His blood is on my hands. I couldn't turn him over. I couldn't turn him over. I couldn't turn him over. I couldn't turn him over. My face was wet. I can't reverse poverty. I couldn't stop the tears then either. Is it an ocean? It is deep enough to drown. I can't get the stain off of that counter. I served meals three times out of six shifts. The routine was interrupted that night. I needed backup. I don't have a lot of information. The caution tape isn't the best waiting area. "No officer, he was just lying there in a puddle of blood when I found him. We have cameras but he falls in a blind spot." I can't say his name, but I remember it. You read this. I shake. I'm writing this, but I'm shaking. I can't sleep some nights. I remember him. I didn't notice him enough in my workdays. My caseload was heavy. My heart is too. I held her hand. She cried. Everyone watched. No one could fix it. The faucet drips and drips. We can't cut the water line. She feels the pain deep in her bones. Take these thoughts. Hold them. I'm so tired. I experienced homelessness as a professional in the same season as my own homelessness. I rented rooms for several months at a time. They didn't last. They never lasted. The case note is an explanation. "Keep it factual." I don't remember his face with his eyes open. I couldn't turn him over. My face is wet. Is this past tense or present? I'm getting worse with stories. I lose myself on the line of a sentence. I lose

myself in the past. I can't sleep. I'm grasping for the family I created. The other half of responsibility doesn't matter. He's an absent existence. Single mothers always need to be on time for daycare. What about support systems? "Shit." I'm as sorry as they come. My life is a thing I couldn't predict but no one can. We all carry the baggage of some kind of tragedy. "Can you help me carry this?" My mood varies. I forget my medication. I judge my reflection. "Come on, get it together." I can't hug my kids. I don't deserve a home. I'm tiptoes in a stranger's house. I carry my needs quietly. I carry my shame alone. I couldn't turn him over. The trauma attaches to me. It's been a year. "What did I just witness?" I can't discern the grief and the regret. I don't know where to put it and I repeat that, but I sit with how I couldn't turn him over and that repeats as a whisper in my ear. A room of case managers were grieving someone we couldn't help. I can't say his name. The debrief was a moment of silence, and I don't have words for myself in privacy late in the evening. I slept a lot since then. I run in my dreams but it's unclear where, and I can't sleep tonight either. The things that haunt me violently shake me awake. I count them and run out of fingers. Some are heavy on my lungs. There's a stabbing pain in my heart. I can't identify a singular suspect. I blame myself. I can't sleep tonight. My face is wet. I can't edit this. I couldn't turn him over.

Say it Louder, Be Strong

The Homeless Chronicles

I've been having these thoughts for years. I don't really understand them all the time. There's so many of them, and sometimes they drown out the reality around me. I guess I've been waiting for them to make sense, but nothing really does anymore. Most days I'm in a weird dissociative state. I can be so idle and alive without presence. It's like I'm the memorial place of what happened to our family and the grief has become me. I'm not sure how to live more than grieve. I struggle with very basic things. There are so many layers of story, and they hold me down. I'm suffocating under the weight of it all and it was harmless at first, but it wasn't. I just couldn't bear to feel the magnitude of it, so I poured it out in doses feeling like I was healing earthquakes when I barely surpassed the speed bumps. There I was pouring and bleeding. There I was honest and vulnerable. There I was as bare as I knew how to be in a new world. There I was learning that you could be so desperate for love that you'd receive it from your enemies and never identify its fraudulent demeanor until the knife was in your back. There I was remembering my broken heart and being handed a new kind of shattering. There I was, remembering heartbreak and dealing with the consequences of allowing the wrong people into a sacred place. There I was, watching the girl I held nightly fall apart and being blamed for the mess. I've known people to put the mask on, replace the bandage, and use wounds as target practice when they need to discredit, hurt, manipulate narratives, and be bigger. I've always let the screamer dominate the conversation.

Emotional Stress is Bad For My Heart

The Homeless Chronicles Meet Why Didn't You Just Leave

Long QT syndrome (LQTS) is heart signaling disorder that can cause fast, chaotic heartbeats (arrhythmias). A heart signaling disorder is also called a heart conduction disorder.

Long QT syndrome can cause sudden fainting and seizures. Young people with LQTS syndrome have an increased risk of sudden death.

Treatment for long QT syndrome includes lifestyle changes and medications to prevent dangerous heartbeats. Sometimes surgery is needed to implant a device to control the heart's rhythm.

If your symptoms are frequent or severe, and you have a high risk of having a life-threatening arrhythmia, you may need to have a pacemaker or implantable cardioverter defibrillator (ICD).

A pacemaker infection is usually treated using a combination of antibiotics and surgery to remove and then replace the pacemaker. If an infection isn't treated, it could spread into your lungs (pneumonia), the lining of your heart (endocarditis), or your blood (sepsis).

Pacemaker-related infections are a special type of bacterial infection, called endocarditis. It's the same life-threatening infection that affects the lining of your heart valves.

With a leaky valve, sometimes not enough blood gets pumped to the rest of the body. Heart valve leakage/regurgitation can force the heart to work harder to do its job. The condition can lead to heart failure, sudden cardiac arrest, and death.

California's Health and Safety Code requires hospitals to have a discharge policy for all patients, including those who are homeless. Hospitals must make prior arrangements for patients, either with family, at a care home, or at another appropriate agency, the code says.

During 2015–2018, there were annual averages of 42 ED visits per 100 total population, 42 ED visits per 100 non-homeless persons, and 203 ED visits per 100 homeless persons. Within each region, the rate of ED visits among homeless persons was higher than the rate for non-homeless persons.

I, thrift store of a woman, did my best.

Caged Birds Really Sing

The Homeless Chronicles

These broken wings fail me. The crickets outside remind me that my senses are capable of discerning reality. The crickets bring me back from the fog of my brain. The confines of this room box me in. These broken wings leave me feeling inadequate. Some birds can't or won't sing. My chest hurts. I sit with the crushing weight of poor health in my youth. This heart doesn't know how to beat. The doctors think I'll be okay, but I know the truth. These broken wings fail me. I feel the Gulf of Mexico flood my heart. There are some things adults couldn't tell me. But it was never a secret for the yelling part. My father loves my mother. He loves her black and blue. This ragged heart is genetic. When I talk back, he scoffs "I think she gets that from you." I remember my mother twenty years ago, but she's mostly a blur in my head. I remember to be quiet when she's sick or sleeping in or sad in the bed. The floors were always clean. These broken wings don't move. Sit still and be quiet. That's what children do. My father made homemade board games. They were unique and he seemed lighter when sharing his creation. Some days the sun overcame the clouds and there was more joy than frustration. These broken wings remind me that I was the baby who had my mama on bedrest for seven months. I was born at a low weight. I was never enough. The walls are plain. The IV drips medicine into my veins. The incision is healing but I don't feel the same. My blood pressure seems high. My heart beats too fast. I can't go out on my own. My balance doesn't last. I'm mostly dizzy. My body is full of medicine and restlessness. I'm a body without a purpose today. I've lost direction. Is it forgetfulness? These broken wings won't fly. This broken bird can't or won't sing.

I've seen the silver line from the corner of my eyes, but it doesn't mean anything. And I'll discharge, but they won't know where to put me next.

There are so Many Unworthy of a Title Things

The Homeless Chronicles

I've let my healing evolve with the gift of his distance. The
nightmares remind me that I haven't forgotten his existence.
There's a suitcase we lost, and some shit from our first home. I
tried to count all the losses, but I lose track when I remember
I'm alone. There's a life that existed before now, and I keep
finding new ways to write about it. There's turbulence in my
mind where old versions of me cling to paper and fight about
it. This healing has been a feeling of falling apart and coming
undone. I was a different woman at the age of twenty-one. I
remember the seasons where my life had a direction, and I
remember the unconditional way my children found me with
affection. The nightmares haven't stopped and I'm running at
the sight of his face too often. There are rooms upon rooms,
grocery store aisles, and houses that I get lost in. I want to find
a person who can help me with my dreams, but I don't know.
That feels like I want to want somebody to help me with his
ghost. The memories are in a place that doesn't erase. It's
amazing how all these years haven't taken the image of his
face away. I try to erase it inch by inch, but my memory always
rewinds. The anger creeps up when a familiar feeling visits. I
feel my blood rise and I know that I'm triggered. But I don't
hold onto loving him or needing him like that broken version
of me did before. It took nearly a decade, but I've finally found
strength to stop banging at that door.

I can be a mad woman; fourth of July fireworks, screaming,
crying, and no place to place the shame. Even in this distance I
can't shake the blame. I wonder if these explosive feelings find

him in his dreams. And if they do, I hope his heart walls burst at the seams. I hope he stumbles into the truth and hates his reflection. I hope it finds him in his happiness because he's denied that recollection. I hope he sees our children's faces as clearly as I see his face in my mind. I hope it rewinds and rewinds and rewinds and rewinds. I hope he can't forget. I hope that he can't pretend. He may be in my nightmares, but the truth is with him. I wonder about his darkness. The hell I found in his eyes. He's just one man with too many lies. Yes, he may have broken his rearview mirror and refused to get it fixed. He doesn't want to see the damage he's caused again. Our children are still crying, and I hope he can hear it. I hope it wakes him up. I hope it breaks him down. I hope he cries hard and cringes at the monster he's found. I hope he sees his reflection, and I hope he finds his heart. But I hope he tries to hold it steady, and it only falls apart. I hope he bleeds slowly. I hope his organs twist and burst. I hope I find it in my heart to stop hoping for his worst. There's a pain in my stomach. There's an ache in my heart. I see him in my dreams and our family is torn apart.

Blue

The Homeless Chronicles

What does blue look like? I could pull hints from a hat. Blue must look like the empty space where you realize you aren't bulletproof. There's a bullet in my blue heart. Or is it more accurate to say the bullet turned my heart blue. It's been choked into a lifeless thing. Blue heart/ blue nights/ blue hope/ blue face/ blue everything/ Or is something here red? Because blood is red, isn't it? Is there anything here that can adequately identify the sad thing my heart is. Did you see the bullet before it got in there? The doctors can't find it, but they've studied the long qt intervals and they hope to uncover reasons. But there's no bullet. It's almost as if I have no reason to be a blue face and choked thing. There's a bullet in my heart. I know it. I felt the impact. I can't imagine pain that isn't because of a bullet in my heart. Haven't you ever heard them talk about heartache? It aches. It's there. Do you understand now? I can't just walk it off or think positively when I'm bleeding this way. My life is flashing before my eyes again in many different shades of blue—I hate this part. The impact makes me dizzy, and this might be the time I won't stay. This is the umpteenth time I've felt the grief pierce me this way. So, what is blue? What does blue look like? When the sun finds me moments after dawn, I don't want to see the truth either. But even sunlight is blue for me. Are you taking your medicine? I don't know, Einstein. Is there a pill specific to grief? Let's see, I'm covered for depression, anxiety, we're good so far on post-traumatic stress disorder, mood stabilizers, and sedatives. Did I miss anything? It's a lot. I'm getting a degree related to this psych world, but all you really need is doses of trauma. Isn't that wild? For me,

blue is found in the laughter of joy. A place I can't go. For me, blue is found in the joy of others. What they see as joy, I can't know. Blue is here beside me as I write. Blue is every minute the sky sits in moonlight. Blue for me is the pillow drenched in tears after a night of sorrow. Blue must look like the sun creeping in as a good attempt for life tomorrow. What is merely a red rose for others is my definition of blue. Gardens, anniversaries, weddings, birthdays, engagements, holidays, and love. Yes, there's more I can list. But they're all blue to me and joy for you. Blue is in the twinkle of Christmas lights on my neighbors' tree. Blue is wedding bells at my best friend's wedding where emptiness isn't a feeling I can flee. My brother had a big wedding back when things weren't blue. I was happy for him and I'm happy for them too. But grief is a knife at my throat. But it isn't a knife that comes unprovoked. Even though it seems weightless, I hate this, but no one asked me how I felt did they? Because life goes on. And I'm not horrible. I feel the blue and it exists with happiness for good moments and milestones, but blue exists with it. Blue always exists with it. Why would anyone ask how I feel? It's written on my face. You can see it in my posture and walk. I'll find laughter when I talk. But it's blue. I am blue. If they asked, they would find responses of self-loathing with mixed signals that I am kind of sort of okay. Because I am blue. And I'll want to believe I'm fine, even though it is not true. Blue, I'm blue. In my reflection I find blue. What do you see? What does blue look like? Blue looks like me. Blue is my reflection in every mirror I see. Blue.

Candy and Social Services

The Homeless Chronicles

No dumping here,
No more dumping here.
You keep the trash you've collected.
Dearly beloved, we are gathered here today, neglected.
Awful things will transpire.
Awful situations will brew.
Warm it up until it's a close resemblance of fire and then pour
it in where scolds are due.
You will reach bottom.
You will beg to be found.
You will scream as crisis blossoms but there's no rescue team
around.
Micro seeds of trouble, the tiniest ones that seem harmless
knock.
You'll be buried in the rubble, and you'll be torn flesh from the
edges of rocks.
You'll weep endless sorrows.
You'll echo tunes of distress.
You'll find a truck to borrow and move each piece of your life
into emotional duress.
The street smells like burned trash.
Your home is ash.
You'll lay your head on the damaged pieces and park by the
sign that says do not pass.
You'll fight the burning of your eyes after nights of sleep
deprivation.
But you'll cut the word survive beside gratitude, at least you
aren't face to pavement.

You'll bang at the walls of nothing.
You'll feel trapped inside of a prison.
There's no escape from the skin you live in.
You'll be flightless.
You'll be fightless.
Nothing you say will change a thing.
You'll be voiceless.
You'll be choiceless.
You'll crave a melody without a way to sing.
You'll need help.
That's when it strikes.
That's when it burns.
That's when you're wrapped in a lonely night.
That's when you lose the will to discern.
That's when you lose the will to fight.
So lay down pretty lady.
Lay down.
Accept your fate.
You're now darling and baby.
You're a nameless fuck face.
When will you stand unashamed?
Your answer is never.
Your body is a property claim and from breast to thigh your
worth is measured.
One and two, spread them, and spread them wide.
Shame never leaves you but in numbness your pain subsides.
One and two, take it, take it all in.
You're such a filthy girl.
He's going to use you again and again.
It's a man's world.
It isn't enough to be taken and used.

It isn't enough to be disregarded.
It isn't enough to be hungry, without shelter, and
brokenhearted.
You also have to open up wide and say that you want it.

My Dreaming is the Leaving

The Homeless Chronicles

I haven't looked at my incision for days. My body is this private healing thing. I've been wearing the same faded sage button up. There are so many days that have passed, and I haven't bothered with changing or being a part of any new days. I'm uncertain on how present I've been, but I'm not entirely absent. I blink in to accommodate the comfort of others. My laughter is misleading. There's a sarcasm in me that's easy natured. If I weren't in my flesh, I wouldn't want to be me or anywhere near me. I hold this honoring those around me. The humor is gratitude. It's odd pleasantries to avoid the sad reality that I'm sad and now I have three incisions. The incisions are sad too. The surgeon is so silent. Can he hear my sad? I've wanted to crawl outside of my skin since I was five years old. Mom and dad were only missing signatures. They were so silent. Dad was sorry and despite the silence we knew they would never sign. Divorce takes too long anyhow. Leaving in peace is easiest. I drag whatever boulder I am with me as I leave. I can never identify the weight of my sad. Is it the wall? Is it the heart? How can I take up less space? I couldn't crawl out of my skin, but I stayed out of the way. My boulder is out of sight.

These incisions are additional to preexisting ghosts and old wounds. I walk as preexisting ghosts waving my old wounds. The doctor came to talk about discharge. A shitty streetlight flickered on and off. I discharged to home. I discharged to nobody and when she calls me somebody I strive for old silence. I strive for the kind of silence that takes up little to no space. I wait for her to leave. I wait for her to find the mess I keep

burying. I'm lost in thought. I've tried losing everyone in translation. I've walked. I've spun. I've fallen. I've stumbled. I've run. I'm not alone. I'm in a state of constant processing. Can anyone else hear my sad? I need a room check. Is it empty yet? But the truth is that the right people will never leave with every reason to. And the truth is that the wrong people will always leave regardless of reasons not to. And the truth is that silence isn't always peace. But leaving can be a gift. You know, it's kind of like the trash taking itself out with the wrong people. Haven't you heard that one? Rewind, company is coming over. I made myself a ghost. It's so hard to hold back an itchy throat. Fast forward, I stare at incoming messages. I need five business days to respond. I need days. I need time. I need days upon days. I'm still processing. I make myself a ghost.

I did sign the papers. Maybe they'll grow to hate me, but I can't build walls out of this distance. But I won't point fingers at who can and who will build walls. They aren't important. Tomorrow I'll be in a new time zone and next week I'll be a memory. What I mean is that it doesn't matter where I go. What I mean to say is that distance can never change the love. I stumble over health. I stumble over mental health. I stumble over mental mess. I have reasons or the reasons are excuses. The room isn't empty. I'm not alone. The hospital doesn't know where to place me. I don't have cognitive enough senses to understand what day it is, but I leave anyway. I drag whatever boulder I am with me as I leave. I can never identify the weight of my sad. Is it the wall? Is it the heart? How can I take up less space?

How many incisions will it take to fix me? The doctors are congregating in the hallways, and I know they're whispering but

this medical practice is wearing me out. I didn't learn how to sew, and it was better to admit it and pass the task off. I don't understand what happens when doctors talk to other doctors. How many incisions will it take? I know how to leave. Fight, flight, or freeze are my daily routine. This year's circumstances excuse my absence which is good for all my mental trips away from reality, but I haven't seen my incisions in a few days. That's how I've been measuring my level of okay. I know that my body is healing more than the physically breaking I feel. The wrong people always leave. The right people know visiting hours. I wake up to this life where a children size void exists. The medication causes drowsiness. I drag whatever boulder I am with me as I dream.

Postoperative

The Homeless Chronicles

In the after moments, I'm here in a bed listening to monitors beep and IVs drip. I'm staring out of the big hospital window where there's this rock wall lining the freeway exit onto Hollywood Boulevard. In the after moments, the fear doesn't swallow me and erase me. Instead, it eats at tearing flesh with slowed desire. It's nipping at these wounds with endless layers of torture. I'll be here for a while. Perhaps, the dying was the escape. I'll be here for a while. The ache, lidocaine prisms are painted on my skin. They dance with my pain. The pain is a silent and raw thing. It aches. It screams but it seems too young to be here aching like this. I have conversations with your god, but he hasn't answered my questions. Is kneeling to him the only way you'll see my strength? How humble it must be to suffer a holy death. There's a silence about obscurity. If a tree falls and no one is around, you know? And you. You're my audience, right? I'm sick. If domestic violence is an equation, then social services, court, and hospitals are the answer. Supposedly. But maybe we can call it English and knot the truth obscurely into a run on sentence. Have you heard this story before? C- tops. There isn't a dead end for the thoughts nursed while in a hospital bed.

I have conversations with myself too. I dissect each piece of memory. I'm wrestling with existence trying to find reasons for the pain. The animal inside of you can't see me hurting, but the animal inside of me learned to call the misery home. The animal of flesh was born to hunt and to be hunted. The animal of flesh was born to wound and to be wounded. The animal of flesh was

113

born to kill. It was born to die and somehow, I am all of this in this moment.

The IV drips and although it's falling in autumn, much different than any fall I'd ever had, I can vaguely remember a fall that's different than now. I can vaguely remember honeysuckle baby eyes staring up at me as the swing squeaks back and forth. Her eyes smiled. I can vaguely remember that autumn where I stumbled into a false version of love. I can vaguely remember lips and hands. I unknowingly blinded myself into a pain like misery. I can vaguely remember any autumn's that came before this one. I can barely remember the Brooklyn Bridge. I can barely remember lips on lips or laughter in the park. I can barely remember promises made and promises broken. In autumn's past, no one could've known I'd be here. Orange monitor lights combine itself with the IV bag in the midnight hours of this hospital room. It creates a settling orange scene that I can't look away from. I've been so many places. The miles are endless stories. I visited those places I hoped I'd belong, because maybe it was better than midnights spent alone. I haven't forgotten how hard it was to breathe in that car, and how hard I tried. I can barely remember California beaches before now. I can barely remember standing in the ocean full of surrender with nothing more to surrender to than myself and all the grief I've been carrying. I can barely remember winter-like mornings when he kissed me before formation and the sound of his boots walking away. I can barely compartmentalize all these lives anymore.

The IV drips and I'm someone else now. I'm attached to all these monitors. It seems that I'm getting more vulnerable by the minute. The nurse explains the life vest and how to properly

assemble it. I stare off into space barely listening. So, this is how we keep my heart safe. If only. It feels that I've stepped outside of my life four years ago and I'm getting too far away from it with each passing year. My reflection has even started to ask of my first name. I can barely face myself in the mirror because some mornings I don't know who that is, and I never liked eye contact with strangers.

Extraction. Another piece of my existence isn't there and I'm voided without that pulsating reminder attached to my heart. It's surreal because just like everything else I thought I couldn't live without it was taken. It's surreal because it's grown sick. My body has commonly attacked itself in this war against itself. Here, in this flesh, we attack what we don't understand. My flaws meet me at night when I'm all I have, and questions linger. The answers are a deep dig, so I bury the questions under layers of self-destruction. It'll take a lifetime to understand. In the moments where darkness increases its heaviness it would pulse harder and catch me short of breath. Flutter waves rushed in, only enough to get my attention. It was a reminder that maybe it fought for me more than I ever fought for myself. Cheers to pacemakers everywhere. 30-year-olds don't go to those parties. We can admit it. In the after moments, I'm alone wrestling with doubts of my own will for self-preservation. Aren't I too young to be here aching? Can we admit that too? In the after moments, I try to listen for directions and remember to press the right buttons at the right times to sustain safety and lessen the fear of cardiac death. Self-preservation doesn't come easy to me. I needed that fluttering reminder. And on top of all things poured here, we still don't know where I'll discharge to.

There are nails scratching at my door, this door that isn't really mine.
Desperate fingers slide underneath,
they do this all the time.

I think they're attached to a hand, and I think the hand is attached to an arm.
There's a brain connected somewhere, and although shaken you know crazy has its charm.

I think there's a heart in her chest, because crazy is usually a she.
She's a mad woman and through mud or ashes she's like the wreckage; direct reflection of me.

She'll greet you with eyes attached to a questionable doubled head, hallucinations tend to blur.
Keep digging up wreckage and you're sure to uncover terror, you're sure to uncover her.

There are nails scratching at my door, and I'd love to go to sleep.
But whenever I close my eyes those desperate fingers of hers tend to slide underneath.

Is there a haunting in my mind, or is there a haunting at my door?
Mental madness defined, and explanations are yet to be explored.

There are nails scratching at my door, and something seems to be terribly dark and wrong.
There's an unsettling tear in my center of peace, and I shouldn't feel this way at home.

The door is an illusion, and I'm in the center of the world without a place to rest my troubled mind.
Society stares in judgement without solution, they do this all the time.

How to be Homeless

The Homeless Chronicles

I. Lean on the emotional stability of broken youth

II. Remember, we aren't bulletproof

III. Love the wrong man with your whole heart

IV. Build a future on promises and watch it fall apart

V. Collect excuses after blue mistakes and frame potential to admire

VI. Stir the anger in the devil's heart and watch hate spark a flame that elevates a fire

VII. Have the capacity to stand back up and regret accepted violence as passion

VIII. Sweep through debris and try to create a home from the ashes

IX. Scream for help when your hope is blown away into the wind

X. Have the capacity to stand back up again

XI. Drive far away and let your knees find prayer

XII. Wait for help even if no one's there

XIII. Labor in hell's sun and let sweat feel like hope

XIV. Drown in the terror of night and watch your efforts float

XV. Take your heart out of your own chest

XVI. Give the entirety of your heart to someone else

XVII. Resent neighborhoods who survived the fire and cry about how heaven's a lost star

XVIII. Wish on a star and for hundreds of days sleep in your car

XIX. Run from chaos and be ready to defend yourself against assault

XX. Lock away memories in the trunk of your car; especially those most dear to your heart

XXI. Bleed yesterday's pain on today's white linen

XXII. Run away from everyone; especially your reflection

XXIII. Skip 4 meals and let your head ache from the pain

XXIV. Change who you are by scribbling over your given name
　　　XXV. Dig a grave and park by the end of the earth
XXVI. Hold umbilical disconnect and memories of giving birth
XVII. Sell whatever you can and sustain in any way you can find
　　XXVIII. Help the woman without shoes, smile, give her mine
　　XXIX. Write poetry from the blue of sorrow and wonder when
　　　　　　　you'll have your next meal
　　XXX. Build a wall around reality because "sex trafficking is
　　　　　　　real"
　　　　XXXI. Breathe without living
　　　　XXXII. Scream about suicide
XXXIII. Be startled in your car; the banging and screaming
　　XXXIV. Wish on a star; maybe you're dreaming
XXXV. Walk on the beach and count every lost second, minute,
　　　　　　　week, month, and year
　　XXXVI. Plan to be okay but also plan to jump off the pier
　　XXXVII. Pay attention to the permanent storm in your heart
XXXVIII. Smile at the office and return to your loneliness to fall
　　　　　　　apart
　　XXXIX. Remember the descriptions of pimps and park in
　　　　　　　different places
　　　XL. Tell god to fuck off but pray the pain erases
　XLI. Apply for shelter anyplace with vacancies and network
　　　　　　　at agencies nearby
　　XLII. Work with the population of your reflection and
　　　　　　　secretly take breaks to cry
XLIII. Don't forget a gym membership. Public restrooms can
　　　　　　　only go so far
　　XLIV. Storage units help if you can't discretely keep your
　　　　　　　belongings in your car

XLV. Tweakers and other misplaced faces will argue most of
the night
XLVI. Remember to isolate; there's no need to be polite
XLVII. Exhaustion will meet you daily and you'll need more
healthcare because of how sick you'll be from stress
XLVIII. But perseverance is key just listen to me and try your
fucking best

This Land is Your Land

The Homeless Chronicles

The United States has the largest amount of homelessness among women. Homeless women suffer disproportionately from every catastrophe specific to their gender and race. The issues they face reflect low-income women and are further compounded for women of color. These issues obstruct all women, but not with the same intensity and frequency.

100% of homeless women have experienced some form of domestic or sexual violence at one point in their lives. 22 - 57% of all homeless women report that domestic violence was the immediate cause of their homelessness. The regions and types of studies may differ, but they aren't necessarily contrasting. They are alike and reflect the impacts of violence. A study compared both homeless, and very poor, housed women to determine the higher rates of intimate partner violence. The study found that while violence was high in both groups, homeless women experienced it at a higher rate (63.3 percent) compared to poor, housed women (58 percent). More than 36% of homeless women report that their partner threatened to kill them, compared to 31% of housed women. Almost 27% of homeless women and 19.5% of poor, housed women needed to receive medical treatment because of physical violence. Compounding the challenges faced by low-income women in violent relationships are rules that govern public housing. Through a "one strike" policy, women may be evicted for a violent activity regardless of the cause or circumstances.

Of the 46.2 million Americans currently living in poverty, almost 25 million (55 percent) are women. There has never been a single year on record when women living in poverty did not outnumber their male counterparts. The poverty rate among women climbed to 16.2% in 2011 from 13.9% in 2009, the highest in 17 years. The male poverty rate was lower, rising to 14% in 2011 from 10.5% in 2009. Over 17 million women lived in poverty in 2010, including more than 7.5 million in extreme poverty, with an income below half of the federal poverty line, defined as $11,139 for an individual.

The typical woman who worked full-time, year-round in 2010 still made only 77 cents for each dollar earned by her male counterpart. The wage gap for minority women is even worse.

Women experiencing homelessness are a heterogeneous group in terms of age, race/ethnicity, duration and cause of homelessness. One-third of a nationwide sample of homeless women met all three criteria in the definition of chronic homeless individuals: they had mental health or substance abuse problems, were homeless 365 days or more, and were unaccompanied individuals. Women constitute one out of four chronically homeless adults. Unmarried women—particularly unmarried mothers and the elderly—represent the largest share of adults in need of government services, such as public assistance, housing assistance and food stamps.

A vast majority of women who have been on the streets for longer than six months are likely to have been assaulted and/or raped.

As an essential survival tactic, homeless women make themselves as invisible as possible so as not to be noticed. This

survival tactic has practical implications as single, homeless women are also nearly invisible from public view and from media images depicting homelessness.

Compared to the general population of women, homeless women's health disparities include higher rates of mortality, poor health status, mental illness, substance abuse, victimization, and poor birth outcomes.

The higher prevalence of illness among homeless women is due, in part, to exposure to the elements, violence, poor nutrition, inadequate social support and infectious diseases.

About 50% of homeless women have experienced a major depressive episode since becoming homeless. Compared to housed women, homeless women have three times the rate of Post-Traumatic Stress Disorder (36 percent) and twice the rate of drug and alcohol dependencies (41 percent).

For homeless and marginally housed women, the life expectancy at age 25 is 52 years—seven years lower than the general population, and five years lower than the poorest income group.

"Signing our rights away contributed to the trauma."

Birth moth·er

Birthmothers are a social construction.

The term birthmother was devised by adoption professionals to reduce a natural mother to that of a biological function relegating her to the status of a mother.

This term marginalizes mothers and creates a role for them in society which does not allow them to fully embrace their lived experiences as a mother, but instead implies that the sacred bond of mother and child ends at birth and that her role is secondary to other mothers in society.

Once stigma is attached to a topic it's hard to present in a positive image. You may experience lower self-esteem in situations where the topic pertains to you. This debases one's identity. It can feel discrediting.

I became what society knows as a birthmother on December 28th of 2017. When I relinquished parental rights, I didn't know what I know now. And if I knew, my signature wouldn't have even come close to being on those lines.

The Baby Scoop Error

I Think the Error in That Era Continued

The doorway is an entrance for history
Our ancestors were never a mystery
Hold this baby/ umbilical cord like century/ rock a bye
infertility

"Do you take this bride?
Let us take her baby.
She's an unmarried lie.
She's an unworthy lady."

Now the highest will lay her down to sleep
They'll close their eyes and hide the moments she weeps
In the bible it must quote that their local pastor decides what's
best for the child,
A comma isn't strong enough to hold their sentence outside of
denial.

Their gavel bangs one, two, three/ they decide biological
needs/ they'll succeed/ grief indeed bleeds
Once upon a time, they erased the mother to elevate good
deeds

 I have a lot to say; don't tell me it's hearsay
 Adoptees shout about what went wrong yesterday
 And *today*

When the saint's church declares a time; they'll lay those
children down to sleep

They won't whisper about the lies; they'll stay loyal to the
secrets they keep

Family picture/ heartbroken/ break the mirror/ nothing was
stolen

The saints won't let ~~birth~~ mothers hold their babies
The intention was to spare her; what a poor unholy lady
No one on earth has ears for her kind of crazy
But the tragedy of what happened also left me hazy.

Once upon a time/ I wished upon a star/ I held our family in
poverty/ arms wide enough for four hearts/
Once upon a time/ I accepted anything grace would give to me.
And this story is larger than mine, even while it's sorrow and
hazy memory.

Dear those I love, I'm deeply sorry we aren't together.
I'll wait in the storm, saving room under this umbrella.
Dear those I love; I'll love you forever.
Signed and sealed with hope, your ~~birth~~ mother.

Four as a Constellation

Love Isn't a Big Enough Word

I love the way your thoughts dance. I find colors in your spirit.
I think your existence is music, and when you smile, I can hear
it.
I love the way you speak even when your words are multiplied
and excited.
I love you especially then. Your zest for life so ignited.
I love you when you cry. I love you in your moments of
blue.
I love you despite any distance. My heart is forever with you.
I love you through the seasons of time. I love you through the
lessons.
Every creation has its garden and you're a blooming blessing.
I'll always be your first home. I admire the ways that you
bloom.
I know that we're far apart, but I hope to see you soon.
I breathe every morning and you're my reason why.
Through the miles I'll think of you often.
We'll always be under the same sky.
The formation of your existence is a twinkling magic I love to
see.
You're a treasure within perseverance, my favorite parts of me.
I can't count every reason why I love you.
I wish I could capture them all and seal them in jars.
Let the endless nature of the galaxy assure you, you're perfect
just the way you are.
Your eyes form the magic of illumination.
Your being gives me light in the dark that I've become.

And when I fly out of midnight into dawn, I'll try not to fly too close to the sun.

You're magic in the infinite ways of the stars that give light to the darkest of skies.

When I place my hand over my chest finding hope in this beating heart, you'll be the reason why.

The Grief I Carry

I Think the Error in That Era Continued

it rushes in like a wave to the shore/
desperation to its knees/
children return home from school/
gasps of air/
i cannot breathe /

June of 2021

I Think the Error in That Era Continued

I'm proud of you for surviving very terrible things.

It Wasn't Supposed to be This Way

I Think the Error in That Era Continued

I watch the light go out in my son's eyes once a year.

But Really, Why Didn't You Just Leave

I Think the Error in That Era Continued

I. Family violence

II. Family cycles

III. Domestic violence later in adulthood

IV. Decade long abuse following vows

V. Military chain of command protection over veteran at the expense of spouse

VI. Religious abuse combined

VII. Financial distress as result of abuse

VIII. Turbulent series of events

IX. Separation

X. Gaslighting

XI. Resources

XII. Fought for two-year veteran's housing voucher using police reports

XIII. and restraining order obtained against abuser

XIV. Permanent restraining order

XV. Therapy

XVI. Court hearings

XVII. Safety threats

XVIII. Break ins

XIX. CASA

XX. GAL

XXI. VAWA

XXII. Homelessness

XXIII. Programs throughout county while hitting dead ends for help

XXIV. Advocacy for children

An Ode to the Fight Song

I Think the Error in That Era Continued

I'm stuck under the weight of this lonely bed. The inadequacies repeat on a loop in my head. I stare too long when I sign my name now. If you ever want to haunt a blind world, I'll show you how. If only they'd open their eyes, I could put down the blame. My heartbeat flatlines from this emotional pain. Legal ink is a brick wall in our lives. I plead with someone's god to put down the knives. Is there a cookie cutter way to separate a child from their family? When I see the rearview mirror reality feels like insanity. December tears are an ocean of regret. I've tried but I haven't learned to swim yet. My babies, my loves, my heart, you're every single star in my sky. I owe you so much more of me in this lifetime. I crawl backwards and feel for the entrance of our first home in 2016. Life can be so fucking mean. Summer will come each year and I'll be with those I love. One visit a year. Is it ever enough? Please use my pen and write it in bold print. I hate private adoption agencies and resent every cent those families spent. If I could go back in time, we'd be together and let some people have distance instead of access to our lives. The anger from loss is the fuel to this fire. Fist to hand. I bury the anger inside of myself even when the blame belongs to someone else. It's funny how people judge but don't offer a hand. The anger is buried. Fist to hand. Sometimes hands aren't hands and hands aren't help. This happens when someone helps themselves at the expense of your downfall instead of providing help. Sometimes help is obligation. Sometimes help is manipulation. But this kind of help led to this current devastation. Baby, just to be clear, I shed tears when I hear fight song too. My love, my heart, and my home are always with you.

"Self-Care" Isn't a Thing That Helps Grief

I Think the Error in That Era Continued

The air has a hint of fall in it. The chill is slightly crisp and breezy. I've gotten into routine after almost four years of sleeping in my car. This is as normal as normalcy has been for me. I've already put three earrings in. I look as though I had full access to vanity and a restroom. I'm reaching for my fourth and nearly ready to walk into the salon before I notice. A short yellow bus appeared. It's stopped by a shelter I won't name. I know the city I'm in. It's where we began to fall apart. The buildings blend. That's what makes that shelter so smart. The police station is around the corner and that's where the advocate met us. We followed her to this building as discreetly as possible. It's a five-minute walk and two-minute drive, if that. We parked, I parked but poorly. I was all nerves and foggy, too foggy for any of it to be real. It's almost four years later and I still come to the salon closest to that shelter. They're always able to squeeze me in and especially since the world has fallen into a pandemic that's been convenient. My appointment is in twenty minutes. I'm early. Or I was early before getting caught in this moment where I'm frozen and watching as the lights on the bus blink for traffic to stop. Children get off the bus. In my head it's December again. It's December 7th of 2017, and I'm waiting on my own children. I was late that day, so I guess they waited on me. But we were going to meet the adoptive parents whose profile I'd viewed a month earlier. In three weeks, our lives would change or end together or change for good, I still haven't decided. In reality, it's October of 2021 and I am now five minutes late and the bus had gone as quickly as it appeared. I stared at the building and blinked before looking down at my

dashboard. I know it has been a long time now and I'm a singular situation. I'm a lonely branch reaching for what should be a family tree. The building hasn't changed but I'm sure the families they serve have. Maybe the man with kind eyes is still passing out food. Maybe there's a new family of five occupying unit 8. Maybe there are holiday cupcakes in donations and maybe they will play just outside of the door for their mother to still have eyes on them. I remember being those eyes and feeling so little. But I also remember playing soccer with my children and other kids. The goal was the fence. I miss that life. I convinced myself and shrunk so far into nothing that when I signed those papers, I'm sure I wasn't me. And now I'm even less of that woman and there's a children size void in me daily. I'll walk into the salon. The hairstylist will complete a color and style. It'll remind me of the loss. I'll walk out, but I'll still be nothing.

Experiencing Today

I Think the Error in That Era Continued

I hold on to my now/
The broken pieces that cut my spirit/
The piercing of an existence that recognized violence as family
and never feared it/
I hold on to my now/
The stolen moments that leave me without/
The nighttime abandon and the internal war throughout/
I hold on to my now/
Time that changes hands on a clock without ever changing my
situation/
Shockwaves of trauma never forgotten/
Harboring eulogy contemplation/
I hold on to now/
The starving void without a family/
The humility of without/
The crying at random but I'm never sure of what it's about/
I hold on to my now/
The breaking of lonely and shattering of a life/
The hiding spot for missing bones/
The home of chaos and strife/
I hold on to my now/
The breathless and hopeless in suffering/
The wrapped in borrowed sunshine yet inevitable shuddering/
I hold on to my now/
The storm of sorrow and flood of flowing sadness/
The happening of aging/
The fading of a past/
The dark/

The madness/
I hold on to my now/
The growing without moving/
And moving without leaving/
Moving on without believing/
Mask tomorrow/
Deceiving/
I hold on to my now/
The happening of each day despite the weight of grief/
The ways function isn't negotiable/
The ways sadness in someone's eyes can still speak/
I hold on to my now/
The lingering of depression/
Awareness of the lessons/
The struggle to count past one hand when counting blessings/
I hold on to my now/
The lack of energy to hold a brick and build a home/
The falling of apart/
The tragic/
The alone/
I hold on to my now/
The ways one pillow can hold so many secrets and sorrow/
The collection of lyrical correlation over speakers when I need
it/
The hope that small moments of now bring tomorrow/
I hold on to my now and the wish to be near the ones that own
my heart/
I hold on to my now as I keep myself from falling too much
apart/
I hold on to my now/
The acceptance of reality/

The left-over blood on my hands/
The grief/
The ache/
The casualty/
I hold on to my now/
The work healing must be/
The on my knees at 2am part/
The hopeful/
The strong/
Me/
I hold on to my now/
I hold the story I wish wasn't written/
I accept the words that's hard to hear/
I carry the ache /
It's forgiven/
I hold on to my now/
And I've learned to hold on to the strength that carries me through/
Meditate and stay/
Anchor the connection/
Forever love you/

My Reflection Melts, it's Probably the Medication
Life Post Adoption, Suicidality, and Other Crisis

I'm not sad today. But something is pulling me into the dark. I'm imagining scenarios where I meet death. What's screaming my name? Who's screaming my name? An echoed laugh follows me out of that thought.

I'm not sad today, and that's good because I don't have room to be. It's just me and myself because I no longer believe. My sister will send me a prayer and I'll read it out of respect for her time. I'll search the lines for any hope that I can find. But I don't believe these anymore. I don't look above. I don't pocket holy love and pray into the nothingness around me. I don't find the obligation comforting or grounding.

I don't believe, but those words are beautiful even though they weigh absolutely nothing. Maybe they resemble poetry because that's the only thing I remain connected to. Stanzas form in my mind when I look out of a window. Speak to me. Is this like a proverb? Can the faith I have between stanzas save me?

It isn't a proverb but it's a lifeline and I'll cling to it like it's my last breath. The rhyming repetition and emotion keeps me alive.

I'm real within these emotions. I'm feeling something in this voided existence. This body is connected to a life. This body, this flesh, and the cold under my feet when I walk the halls at 3am say I am real. I feel it. I feel the texture. I feel it under my feet. I pay attention to the movement. I pay attention to the

weight. I pay attention to the connection. I pay attention to where I am and how it feels to move along.

There's sadness. I feel it in my heart. I feel it sink. I feel it consume the foundation of where my existence begins. I feel it ache and twist into some kind of existential pain. It grabs my attention in the mornings before school drop offs.

I feel it in my gut, waiting and wondering when I didn't know how long it would last. It reminds me of the places in me that grieved a marriage I didn't miss. Yet, It's familiar and significant. It is real, as real as those moments that are only memory now. It's as real as that day where I signed over parental consent. A victory was in our rearview, but it wasn't enough. It's as real as that floating memory and the parts of me that wish it wasn't real. It's as real as that desperate plea to turn back time. It's as real as that place in me that begs for difference.

I'm not sad today, but my veins are full of regret. It's beginning to feel hard to tell the difference between regret and grief. The hurts are similar, and my heart condition is the same. What is this thing that grows more withered every moment? Is it really a heart, the most important organ? I find disbelief with that thought. What about the brain? It's hard to understand which pain is being processed where. When I look back into the past, our past, I remember these tangible things that aren't tangible anymore. I remember catholic churches and family events. I remember the nice older couple who helped us get furniture on New Year's Day. They even looked at our van when it wouldn't start. I remember the chili in the slow cooker and

reading stories after 8pm on our couch. I remember never having room in my bed and how it still made me happy. Their rooms were empty because they'd rather be near me and together. These days weren't fictitious but somehow this moment seems disconnected from that part of me because I'm not her maybe or not anymore at least, but nonetheless, it seems so far away, like a lifetime ago. I'm not good with compartmentalizing and today my reflection is someone, but yesterday my reflection was someone to. And the weight on my heart grows even when yesterday's reflection feels lifetimes away. I'm dying. I'm dying. I'm dying. I'm dying. And the problem is that I've been dying but life remains at my throat with all of these demands and obligations. I. Don't. Know. How. To. Live. Because I don't know who I'm supposed to be. The entire world is closing in on me. My reflection, I have a question, who are you?

Did You Know the Deceased

Life Post Adoption, Suicidality, and Other Crisis

I am dying between these lines/
I'm bleeding out and you think I'm fine/
I am drowning here and now/
To haunt a blind world/
I'll show you how/
There are eyes that don't see the pain and the defeat/
But there are eyes like these that scream sadness and never speak/
I hold the parts of broken that are ugly and full of shame/
I am a reflection of hopeless/
I swallow the reality/
I choke on the blame/
I am dying here but you think I'm okay/
I am fading away/
I can teach you how to leave/
But I haven't learned how to stay/
I am dying/
I am nothing/
No one is home/
Somewhere deep inside I knew I'd die alone/
I've dug and scratched through this mud for hope/
My reflection is a distant memory/
Let's give up the ghost/

While Spiritual Growth is by Nature Challenging, it Doesn't Have to be That Way all the Time

Life Post Adoption, Suicidality, and Other Crisis

I've been thinking about otters. Studies have proved otters to be a keystone species. This means that their role in their environment has a greater effect than other species. Otters are noted to be top predators and critical to keep balance of nearshore ecosystems. This includes kelp forests, embayments, and estuaries. In fact, without otters' sea urchins could overpopulate the sea floor and devour kelp forests that provide cover and food for other marine animals. Because sea otters maintain healthy kelp forests, they indirectly help reduce levels of atmospheric carbon dioxide among other environment benefits. This basically makes otters the superheroes of the sea. These cute little sea protectors are a passover thought. I've watched them while at the zoo. I've always been fascinated with them. We overlook their capabilities. We forget that they were in danger of extinction, and despite recovery, they're still considered one of the greatest successes in marine conservation, and sea otters are classified as endangered because they are still vulnerable to many anthropogenic threats. I read a lot about otters recently and have developed an adoration. I can't explain it. It's somewhat of a respect for their resilience. Thinking of it, it reminds me of that "what doesn't kill you makes you stronger" expression. I consider my own trauma and remember that I didn't need to be stronger. I needed to be safe. These otters have proven that recovery is possible. They sustained and continue to be keystone animals. Didn't I survive too? In fact, I've interacted with other survivors of every kind in different groups. These people survived and many of us go on to put out little fires that

contribute to lessening violence, pleading for better laws and healthy environments, creating a better world around us for others, and spreading awareness for our causes. I get in my head and now I think about survivors who become advocates of any kind. It reminds me of the similar phoenix rising the otters accomplished. This is recovery while still being effective to a cause where advocates themselves weren't safe. I do appreciate a trying repurpose story. And I need a break from the internal monologue we survivors have with our abusers in our heads. I'm still learning to reframe things, and I feel stronger when victimhood isn't the center of my world.

Savannah Undone

Life Post Adoption, Suicidality, and Other Crisis

Can you make me holy?
I feel no glory.
I hate the song that's been on repeat.
I don't know how to get out of this abandoned home.
I am dizzy from this spiraling story and feeling too weak.
I'm tired of being so alone.
Can you make me holy?
I feel the aches of mother nature crack the insides of my chest.
This is a sad story.
I keep wondering how many pages are left.
Can you make me holy?
I'm doing my very best.
I won't ever be the same.
The birth certificates reflect four different names.
I am in chains.
This life is strange.
I'm in pieces.
I'm still here but it hurts to remain.
Can you make me holy?
I am buckets of tears.
I am a reflection of shame.
I am missing out on the important years.
Can you make me holy?
Can you clean this tainted person I am?
Can you make my holy?
Will I be okay?
I've fought as long as I can.

ambiguous blue

I Think the Error in That Era Continued

i'm hoping again/
i'm pulling heaven down/
i'm chasing you in my dreams/
i'm searching for your face in crowds/

Is This Route 66

Life Post Adoption, Suicidality, and Other Crisis

Once a year I follow the fear watching highway signs
and listening to breaking.
I shake myself awake,
a little water in my face,
and ignore the agony of aching.
If my entire existence sits in one adjective,
it would be *emptied* without question.
At night I rest my head on less than the breathless hope I aspire
for
and find discomfort upon all the lessons.
Empty, vacant, blank, void, lacking contents which could be or
should be present.
Empty suggests a complete absence of contents
and in my floating
I'm convinced that I don't equal into the whole that should be
my presence.
I hate street signs throughout this path that I've traced my
fingers along as I've remembered previous years and those
emotions.
I could flood this interstate with every tear I've shed from this
mistake and drown in the reality of that ocean.
I'm absent and on my way all in one effort and that part equals
complete insanity.
My heart knows what I wish others could grasp but I'm too
voided to paint strokes of awakening for humanity.

To the Man Who Was More Wreckage Than Home,

Life Post Adoption, Suicidality, and Other Crisis

One of my favorite pictures was taken during the spring of 2017. This was captured during a time where I felt I knew more about gardening than I actually did. Silly me, I couldn't recognize dead roses when they were given to me. I couldn't breathe them back into life, even if I tried. But we're withering. I could tell. That's the crisis, even when I'm in the sun feeling healthy. We're withering. Breath was meant to be shared. I could breathe in every word of promise for our future and seal them with the faith of our lips. But it's still nothing. Everything is ashes now. The withering turned into the burning. It was quickly burned in the flames of whatever this reality is. It isn't the reality I look up at the sun for. I know that. I can't even fly on a dream anymore. The butterflies don't visit. I stumble when I try to find the flight away in your eyes. All those promises crush under the weight of your rage. Rage feels red. If I could hold it and embrace the texture red is, it'd be some ungodly weapon once the rage is released. It would have the blood of injury. I nurse the wound. I always tried to fix what was ruined. The rage is a bad memory. It's what was served, and you never asked what I wanted or how it made me feel. Because you didn't care. Nothing could ever stop you from bringing hell into the home that we lived in. I never wanted any of these broken parts. One of my favorite pictures was taken on a clear and sunny day. We were at my friend's baby shower. The clouds rolled in and brought the hurt. She later passed away after childbirth. How quickly does life flicker into grief. How long have I stood with my knees buckling weak and too sad to speak. I learned sad well. Sometimes in silence there's a story that eyes can tell, and I've learned this as

a hard lesson. I understand the reality when I see my reflection. I was too blind as a wife, and you were too reckless as a man. But I let you drive anyway. I hoped we'd be okay. In that picture the way our daughter looks at me stops me in my tracks anytime I see it. Every single day I hold the sincerity of her face that I really needed. Sweet face, hopeful face, young girl, vulnerable girl, innocent girl, we let her down. And I'm really tired of carrying your shame around. I see where blame belongs now that I'm not face to the ground. I said no but you said yes. I ran but you caught me. I screamed but you swung. I cried but you kicked. I cried but you kicked. I cried but you kicked. I went silent and you kicked. And in the time it took you to stop I was blue, a frozen contribution from you. And I saw her. She saw us. The same eyes that looked up at me after your exit. Without you we were such a lighter presence. Thank you for allowing me to believe that it was me who failed her when you carried our family out of the garden it was and into a fire. Somehow, I'm still blue and you're still kicking. But you don't care. I've checked every corner and crevice, but you don't care. I can't find our family anywhere.

If I Could've Went Out Fighting

Life Post Adoption, Suicidality, and Other Crisis

Grief tells me that he's more asshole than heart. Grief wishes his life would fall apart. Grief screams, "hey asshole, do something great." Grief can't remember a time where that rearview mirror held less hate.

Words fail me when I try to describe the immeasurable pain. I look around. There are pictures. There are letters. There are reminders. There is heartache, but there doesn't seem to be a future. I am an island. I try to relate to my neighbor, but they cringe. No one knows what to say. They stare at the wounds and overlook my wings. They turn their head and try not to stare but everyone stares more than they care. This has become a night I cannot write, a morning I cannot face, a feeling I cannot shake, a decision I can't erase, a place I can't go back to, a tomorrow I can't hold on for, a hope I lose sight of, a pain that sinks me, the reason I'll die. It's become less catalyst and more demise and there's lightning flooding the sky. With tears in my eyes, I can't define how shattered I feel. With tears in my eyes, I wish with every fiber of my body that this wasn't real. There are pictures. There are letters. There are memories but I can't see tomorrow. I am in crisis, and I'm too sleepy to maintain hypervigilance. I am in crisis, and it has become a permanent address. I am in crisis, and I can't find my way out. I am in crisis, and this is my life now. No one can save me. I've tried hotlines. I've tried heaven. I've tried licensed professionals. I've tried friends. I've tried love. I've tried attorneys. I've tried pills. I've tried apologies. I've tried explanations. I've tried to stay. I've tried to leave. I've tried to laugh. I've tried to grieve. I've tried to plead. I often cry. I've tried to avoid. I've tried to deny. I place my hand over my broken heart. I wonder if DNA can inherit this part. It beats still, but it skips and I stumble. This existence is real. My words are only mumbled. The doctor said that I should take it easy for awhile. I didn't verbally agree but I managed to nod and

smile. I can't sit with it. I can't finish the feelings. The feeling is a wave, and the tide could kill me. I can't be idle. I can't stand silence. Time hasn't helped. Breathing is violence. Time goes by but the pain lives on. My heart beats still, but it hurts everyday that you're gone. I remember the version of me that existed before all of the grief and pain. The clouds get darker. I'm fumbling in the rain. I am not safe. I am not okay. I won't run, but I can't stay. I don't know where I belong. I feel like a lost cause. Sunset to dawn I'm a mess of flaws. I live a nightmare and I wake up, but it hasn't stopped. I've knocked down doors. I've given it all that I've got. There are pictures. There are letters. There are memories, but we're not together. And these are the words I'll scribble on the last thing I write someday. The translation will scream within ink, the truth that I wasn't okay. I've heard that a broken heart means you were loved, and you loved. Heaven could agree and release four of its finest doves, but it isn't enough. I know everything that I hear. I know it in ways that I recognize but can't feel. I know it like someone who sees everyone else's family portrait. I know it like the ache in my heart and can't ignore it. My rational self can't come out to play, so one day I'll scribble about the memories as a way to capture them on my last day. I'll reach for a reason, anything to hold on. I'll sit with the pain at night and wait until dawn. I'll do this as long as I can fight the grief and doubt. I'll do this until I successfully scratch my way through this existence and crawl out.

There Isn't a Shorter Version

Life Post Adoption, Suicidality, and Other Crisis

The sun is rising again, not here, but somewhere. Long and wide meadows. Families of trees. Families of five. Families of eight. It's inevitable for it to rise, it's usually just a matter of time. Soon, hope pulls at my heart. "I am still here." It's lost in the darkness but wrapped in belief. I sleep all the time. I sleep more than I need to. My body is confused. It must think, "I am a full-sized bed. Therefore, I exist." It cannot see the life that exists outside of slumber. It cannot hear people laughing, or know that people are painting, they're dancing, they're seeing Italy, they're walking by the ocean, and they're watching pink and orange shades say goodbye. They know how a sunset paints the sky. They're awake. How many shades of blue can I be? I couldn't answer this a decade ago, but now we need star counting abilities to even come close. I can show you where it hurts, but how much time do you have? Once upon a time, and it's still piercing. This is the short version. A synopsis of the unthinkable is easier to swallow. Didn't I tell you? I should've sounded off alarms. I should've known better. I should've left sooner. I should've been stronger. It still hurts. These wounds consume my life. I've never known how to swim, but I knew how to walk before the crawl was all I had. Love wasn't supposed to be the only boy I ever kissed, the time I lost my virginity, waiting while he's at boot camp, and calling his violence love. For so long, he was the only one who'd ever touched me. He was the only arms I felt safe in, and it confused the shit out of me because he would console me after he destroyed me. Is this love? His love was that. It wasn't safe. It was first, but it wasn't safe. Maybe it was better than my childhood home, but it reflected something terribly

similar. It was a decade of vows said. It was a lifetime of grief. It was enough of blue to keep me down. It was shame. It was secret. It was that wall with shades of blue where he thought they all looked the same. But it was supposed to be more. I was supposed to be more. Have the babies. Stay home and cook. Be a lady. Worship that holy book. Wake up with him in the morning. Prepare his lunch for work. Open your legs. Open your legs wider. Be smaller. Fit into this box. Be obedient to that man. No. That husband was quite the image in church, but I knew shades of blue then too. Banged head on the dashboard. It was blue. I didn't know how to acknowledge them. I didn't know how to count them. A decade of war and we needed somewhere to go. Corners of my mother's mistakes find me. Broken mirrors and seven years of bad luck find me. Maybe those years repeated. Life was different once upon a time and changing into a new outfit today feels like acceptance of yesterday, but I didn't consent to this. And if I wear the dress, if I paint the wall, if I laugh when I'm able to, then I am saying that this is reality and maybe I'm moving on. But I remember the suitcase and freezing cold. Fuck my tears on that signature line. I don't remember getting back to the shelter after last holding tiny hands and saying goodbye. All I know is that I cried and cried and cried and cried. The months bled into each other, and I would float away. I'd be carried away by sadness and grief. I would disappear and I honestly don't know how I got here today from that point. I taught myself how to dance when everyone was looking and at night the moon was my relief. I survived obviously but how did I get here. I don't remember the road. I don't remember much of the days. I can't tell you how many times I died but man did I ever. I sat with people who thought I was brave. I completed the notes and performed daily tasks. I

drove the car. But I cried and cried and cried. The shades of blue were much too many to count. Oh, how I hurt those I love. The ultrasound pictures sit in my mind. My baby's heartbeat steady and calm. They didn't know then the trauma of separation or how it would feel to live in a home where daddy became the monster. They couldn't predict the churches, the scary nights, the borrowed beds, and unanswered questions. Apologies will do right? Apologies will not do. I look at sky blue and stare at something September. I'm back in our tiny apartment, the third home we'd had since last seeing their father. I am sitting with my four-year-old. She is counting flowers on her hat. She is tapping me for attention, and I am spaced out. We last saw him on a cold day in October. I don't count court appearances. I don't count the faceless man who harassed us after midnight for a year and a half. I wish I remembered the day I fell in love. I'd avoid it like a religious practice. I'd use the memory to wipe my hands. It would be proof that I'm done with bad habits. I wish I could say it was October 18th. I wish I knew the time on the clock where we had last been a family. I wish I knew the time on the clock where something switched in me and I was a fading away mother. But there was a cloud and I'm still sorry for how much of me disappointed and disappeared. This isn't us he said during the first month we were separated but I knew when he said that it was manipulation. I could feel him trying to stich us back together with lies. Saying "no" on that day feels like when the umbilical cord was actually cut. I was half of a mother then. I was losing our family. I was losing my life. I wasn't equipped, just like he said. Inadequacy echoes in my dreams and nobody was coming to save us. Nobody thought our family was worth enough to be a backbone for a mother who was trying. Nobody thought to lend a hand up. We fought though. We fought so hard.

I hold those days. I hold what I can remember of them. And Cheyenne Mountain Zoo is a distant memory but it is our memory. And now I've landed after spiraling for years. I've driven too many miles for too many years, and it isn't much I'm asked to do, but I'm still half of a woman and nothing like a mother. I unexpectedly fade when my grief finds me. It has a consistent way to remind me. The colors are a blur. The colors are too many. Life happens despite my head space. My mind is a fog and it's swallowing my connection to this moment in a gradual mind of steel. It is the kind you don't see happening. I pinch at myself but none of this seems real and I guess I tend to be present but very lost in my head. I am disappearing. It feels like floating, but I know I have a body and a life. I have people who are waiting for a response and a heart that needs more than sleep. I am staring ahead with nothing registering and the colors all look the same, but nothing here makes sense. I can pinch myself but it's already much too late for that. When we paint the wall, I am saying yesterday was real and tomorrow I will live in a reality where I'm not a mother. Is this insanity? The disbelief buries logic. It seems impossible and big. And so, it happens. I fade away and disconnect from the life I have. It is out of my control but at least I understand it. Should I write it on my wrist? "Come back" or "stay." Would it help? Would it even matter? Survival was easier than settling into whatever this is. It isn't bad, but it doesn't feel like it's mine. I don't know what that means. I don't know how to be okay within it. If I looked at my wrist, would I stay? Burn those letters into my skin. Life is moving ahead and I'm still the one who we left behind but the left behind are ones without obligation to participate, and if a tree falls when no one is around who would even notice? But am I left behind or did I stop walking? Who can even tell anymore?

I think I died when my heart was still beating, and I don't know what to do with the minutes after that moment. I don't want them maybe or maybe I don't deserve them but maybe the sun will rise again. Maybe the sun is on its way. Maybe it is patient enough to wait and cheer me on about experiencing today. I blink and blink and blink and I hope that hope is still holding on. I don't know how to wake up, but the sun will rise again.

Four Walls

Life Post Adoption, Suicidality, and Other Crisis

Damn these walls and how they sway my nervous system into action. The thoughts in my head are pieces of me dissolving into subtraction. They're too many until they're not. They're all of me until it's all I've got. Then when my mind goes plop, they haunt me until I rot. But I'm empty all the same. Every inch of my skin remembers his name. There's fresh ink over bruises trying its best to be more of me but tonight it's less. And there's a clatter in this room. I don't know if it's real or the fear I consume. I can't see it or tell its place in proximity but then it feels like something bad has already crawled into me. There's bad things I've already survived, I've convinced myself perhaps, or maybe I lied, but I try to move on and not be a bother. I've always been this way so why does this moment even matter. I'm not a human who climbs the ladder and moves on from said trauma. There's a first aid kit sitting with all its inadequacy in the corner, and I stay on the line with my therapist longer, knowing I'll break again soon. Five things I can see and four things I can touch. I'm standing in a corner, and I've barely woken up.

Holy Days of Obligations

Life Post Adoption, Suicidality, and Other Crisis

Tell your church that you did good/
Tell them you've committed an arson for the sake of the cross/
Tell them you felt the spirit guide you at communion/
Tell them there's no harm and no loss.
Tell your church you did good/
Tell them you've set fire to a family home/
Tell them you're already forgiven/
You've adopted the offspring of that home/
Now they are less alone/

Tell your church you save souls/
They'll sing choruses of praise to the heavens/
Catholic heroes favor your existence/
Hail Mary/
Biggest blessing.

Tell them about the hearts torn from five bodies/
Tell them it was worth it/
On a Sunday morning hymns echo with authority/
Morally wicked/
The churches' purpose.

Holy water purified a dutiful garden/
Scripture granted permission/
Save the children of this world/

161

It is the highest of holy missions.

Tell them you did good/
Tell them you've saved souls by burning a home/
The youth in that home will be taught gratitude and submission
to the cross/
Is there room on such a sacred throne?

Tell them you've torn their hearts out of their bodies/
And there's space to engrave your last name and religion/
Tell them you've done well/
Your reverence in god is your permission.

Tell them you've done well/
Amen/
Praise be to god/
Tell them the trauma and damage isn't real/
Tell them it's a hoax/
The family that existed before is now memory/
They are metaphorical ghosts.

Tell them I've been cutting my wrists/
Tell them to save the blood/
Bless whoever writes my eulogy/
Rest in peace to what was.

Suicide is an unforgivable sin/
It's religiously weighed as murder/

Their church can't acknowledge the pain within/
It's the sanctity that's nurtured.

Theft isn't heinous/
Everything happens for a reason/
Those children needed a home/
They needed a god to believe in.

These acts resemble benevolence/
The kindness is superb/
Theft by deception/
A monetized proverb.

Combine superiority with impoverished/
Which of these belong to heaven/
Communities hide the trash on the streets/
There's a tragedy in oppression.

I can bury the hideous I am/
Don't forget to save the blood/
Dying I'll be/
Rest in peace to what was.

A crime scene I'll be/
Is there a point in which they'll talk about the wounds?
Blend it into crazy/
Create a picture to abide to societal norms/

A woman who lost her way/
Where is the churches' harm?

Tell them you're the hero/
Tell them you'll have communion in the wake of my death/
Tell them you've gained your wings/
There's no need for the children to be upset/
They're blessed.

Tell them you're a hero/
But we both know/
Prayers can't stitch together the cracks/
The children's world explodes.

Tell them they're brave/
Tell them you didn't break their hearts/
Cover them in religion for bandages/
Tell them they've been saved/
May god bless their fresh start.

Tell your church that you did good/
Tell them you've committed an arson for the sake of the cross/
Tell them you felt the spirit guide you at communion/
Tell them there's no harm and no loss.
Tell your church you did good/
Tell them you've set fire to a family home/
Tell them you're already forgiven/
You've adopted the offspring of that home/

Now they are less alone.

Hail Mary, full of grace/
The lord is with thee/
Baptize the stolen parts/
Silence those who see/

How many Sundays will pass?
Nobody is more pure and true/
Cleanse everything in holy water/
Baptize the children too.

Adoption, You're Doing It Wrong
Life Post Adoption, Suicidality, and Other Crisis

Families are ruined by violence.
I repeat, families are ruined by violence.
In the mirror of the savior's perspective, they've requested silence.

I know how to be silent.

Something You Need to Know About Consent

Life Post Adoption, Suicidality, and Other Crisis

I don't recognize her, so vulnerable and exhausted. The woman
who signed those papers, her phantom eyes, heavy heart,
confused face. I don't recognize her at all. It seems unreal.
There's a huge difference between us, it's cognitive presence.

Fire Everywhere

Life Post Adoption, Suicidality, and Other Crisis

The burning house is a distant memory. My sweet 3-year-old explained that a monster ate her old family and now she has a new one. She articulated this after "daddy" turned into a monster. This was in 2017 and months before the private adoption. Her family was changing again even though she wasn't there to witness me signing repeatedly despite tears in my eyes. She wasn't there to give her opinion. She wasn't there to say no. She wasn't there to ask me why. "Baby girl, this is a different kind of beast and it's a lot of reality for someone so young and hopeful. I'm so sorry." Her eyes looked back at me as they loaded the van up like it was some kind of vacation. But it wasn't a vacation, and we'd never have each other again in the same security, legally. The burning house is a distant memory. Fast forward, almost four years later and I feel it. My body is burning too, the silent sensation and lukewarm warning. It's burning too slowly for anyone to notice and too quietly to set off any alarms. The red flags are a neutral distance and tonight I'll cry myself to sleep with shattering surrender without anyone batting an eye. This year makes four years and although they say time heals, I haven't found any relief. They, who are these people that awake a few mornings later, and feel all better? They, the resilient number of societies who've conquered pain throughout the years. They, those who've submitted to a decision they wished they never had to make and carried on. Who are these people? I've met birth mothers, but these women are anything but okay. I've met them and saw pain through their orchestrated smile. I've met them and seen through the toxic positivity they've bought into. I've been there and it stemmed

from the need to survive and lean on a narrative that doesn't break your soul every day. Time hasn't been a soothing factor; it's been a haunting one. Time has stolen years from us. Time has ghosted me in my own life. Time has made me gradually isolated in the loneliness that's settled into my DNA. The loneliness just remains feeling that it's supposed to have more. The loneliness reaches and it's met with nothing in return. Time hasn't healed anything. I'm burning now. I lived in a home that burned, and even the ashes of that tragedy have been carried off by the wind since then. What will happen to my burning existence? What will happen to this temple of a voided person once the fire completes consumption? Will I too travel away with the wind? Will everyone forget my name? Will the ashes dissipate and fade into nothing? I am fading away and the crisis isn't visible to anyone's eyes, but my own. I am leaving and nobody is noticing. The nights I've spent under the stars knowing I've lost everything worth having haven't ended. I sleep and awake to the same tragedy. I've checked every nook, cranny, and corner for hope but it's depleting faster than before. I'm nobody and when nobody wishes on a shooting star nothing happens. This woman is on fire but in the worst possible way. This woman is in trouble and she's worth nothing. The licensed professionals saw monetary value for the children, but the licensed professionals didn't provide any monetary resources to save our family home and they definitely didn't look back once they had assets that created profit for adoption agencies. I didn't know then. I didn't understand that there were agencies paid to facilitate an agenda and preserving our family wasn't that agenda. We were a family of five. Without my children I am one. I'm here in this voided existence grieving what I can't have. They're in a faraway state reaching for the only mother they've

ever known. I signed. I'm the villain here. I was vulnerable, but I signed. I was broken, but I signed. I was naïve, but I signed. I was hopeful, but I signed. I was wrong, but I signed. I was crying too much to see the lines where I would sign, but I still signed. I didn't know. And now that I'm burning inside of this skin, I understand what I should've known then. The licensed professionals understood then, but they didn't carry their ethics with them. They didn't inform me. They coerced me facilitating the agenda that provided children to families who could pay for that service. The children didn't have a voice and I signed anyway. I carry the accountability far more than the adoption professionals and adoptive parents ever will. The accountability and the guilt that are attached to this decision that felt like the only option will follow me for the rest of my days. The trauma and feeling of abandonment will follow my children and all I want is to erase the pain I've caused them. Nobody else is apologizing. The white savior effect is what happens when they can't see the problem in the blessing they were entitled to. They can't see how their help capitalizes on vulnerable families and exploits the same people they aim to help. The blind spots lack compassion and all they hear in the aftermath is applause for this good thing they've done. They can't see the grief or the error in the hero they aim to be. They can't see their white privilege and the flaws in a system that wasn't built to serve needs in vulnerable populations and families. The adoption agency threatened me and intimidated me. I didn't know. I was helpless and without monetary power I was the powerless one in this scenario. Somehow help wasn't available, but this structure of business transactions thrived with our family being the casualty. My children were voiceless entirely, and in our swallowed pain neither of us could do anything to keep us together. We wanted

to be together. But that was silenced because money spoke louder. We didn't have our own lawyer or advocate. It'll be four years this year and everything still hurts. I'm all flames and I still feel powerless. I'm all flames and no good use to anyone anymore. I'm all flames and that decision still feels like more surrender than choice. I'm all flames and filling picture books with what was formerly our family. I'm all flames and tracing my way back into our past looking for ways to erase it. I'm all flames and spiraling slowly. I'm all flames and as absent as ever. I'm all flames, and I'm sorry. I'm all flames and wishing on stars that are intangible from where I'm standing. I'm all flames wondering what they'll do with my ashes. I'm all flames and writing our truth on every wall in bold letters from mere desperation. I'm all flames and I'm less of who I was meant to be every day. I'm all flames and scratching my nails into memories I'm afraid to lose. I'm all flames and I'll be gone at any moment now. I'm burning, and fading away, but I'm still more sorry than anything else.

Stage Left

Life Post Adoption, Suicidality, and Other Crisis

The war in my head is getting harder to ignore. Battles ignite flight responses regularly. I keep logic close but it's never enough to prevent the spiral. I have these annoying urges to run. I am afraid. I am a marathon. I am bleeding memories. I am haunting silence. I'm uncomfortable in my skin. I am stumbling mess. I am here but I'm not present. The thoughts crowd me until I'm backed into the corner of a lion's den. I think I'm more grief than human. I barricade myself behind doors, but they say it isn't normal. Normal people don't sit in the corners of closets and fight with intangible scenarios of danger based on past experiences. Normal people don't do these things. The war, sometimes it has moments of pause and I think I might just survive it. But every time I walk away from the battlefield there are parts of me that are left behind. Now I'm running in circles trying to find parts of myself that I can't live without. I'm retracing steps and doubling back. I'm shining a light and walking slow. I'm trying to remember who I was before. There was a kind face in the crowd that reached for my hand, but I choose to walk barefoot and alone. The face seemed nice, but I think they all seem nice until they are not that way anymore. I run myself in circles until I'm dizzy. I sink into a puddle of despair when disappointment gets bigger than hope. The thoughts get louder and I'm sure I won't survive this. I put my hand over my chest and try to calm the wars within. I'm out of breath. I'm out of time. I can't get up. I'll stay here for a while and although I'll regain composure, it'll happen again. I'll regain composure but my instincts tell me to run away. I'm in a

room full of people. I'm in a moment I want to escape. I'm looking for the exits and practicing speeches about my excuses.

The Sun

Life Post Adoption, Suicidality, and Other Crisis

You, sweet boy, are everything I'll ever need. Aching hearts bruise in the cruelty of distance, and you're all the reason I need to still breathe. You plus three, the four I'll always love more than life itself. Four plus me and I'll never need anyone else. You, sweet boy, you say that I'm your sun. Twelve years of shining in on you and we've only just begun. You, sweet boy, you are my whole entire world and everything in it. If I am the sun, then you are every surrounding planet. If I am your sun, then you are always my reason. Spinning on an axis or still I'll always do my best to be your shining beacon.

Does Anyone Else Dream of Losing Their Children at the Beach

Life Post Adoption, Suicidality, and Other Crisis

There are systems in our country that aren't built to serve equality. There are systems in our country that thrive from oppression. There are systems built around pain, poverty, and misfortune. There are agencies that are paid to facilitate an agenda. There are vulnerable populations that suffer at the hands of these agencies that are said to help those same populations. The money that separates a family could be used to assist that family. People are pouring money into these agencies that are intended to provide children to their consumers. This is a collaborative effort that involves local hospitals and "ethical" social workers, among others. These provide services and build a new family while a family is first torn apart. Let's not forget the order in this professed miracle. Grief is the silent beginning point. These people profit from pain. How many ways can I emphasize the same thing? Usually, the barriers that the family face have a lot to do with poverty. The agencies won't talk to vulnerable parents and families about resources, family preservation, and alternatives to adoption. The vulnerable parents and families are provided with attorneys that work for the adoptive parents and partner with adoption agencies. When you're a part of a vulnerable population, monetary value determines your access to equality & fair treatment. When you're a part of a vulnerable population, the power dynamic will place you below those who have access to more money and resources. You won't be treated fairly. The vulnerable persons are coerced, manipulated, and gaslit into permanent decisions. The system is not on their side. The system is not on my side. The adoption

175

agencies won't tell you this. The weight of accountability that birth parents carry has a lot to do with desperation and complete despair. The resources aren't available. Options are very scarce. Support networks are minimal. The agencies exist as predators who prey on the weaker population to meet their consumer demands. But yes, I signed the papers voluntarily. I couldn't even tell you the colors of the walls around me or what day of the week it was, but I signed. I remember teary eyes. I remember surrender. This is what the adoption agencies won't tell you

First Days of Christmas

Life Post Adoption, Suicidality, and Other Crisis

I stumbled over caught breath in my lungs. I tried to keep my heart contained in my body as the beats intensified. It attempts to beat out of my chest in this pattern of bad habit. My mind was everywhere, and my body was brick. I was really still, and still trying to catch my breath after lost battles. I was really still, and still trying to catch my breath from banging on locked doors. I was really still, and still trying to catch my breath on distant memories. I was still, and still trying to catch my breath after the grief struck like a train. And I'll still be gasping for air when it hits again. One long inhale and exhale freed tension in my body. The weight lessened as I reminded myself to breathe. The aisles in stores are decorated for Christmas already and I'm an unraveling mess at the thought of any jingled bell. The songs still carry a faint feeling of nostalgia, but I still ache under the weight of their melodies. The twenty-eighth day of December makes another year since complete despair changed the course of our lives. Time hasn't lessened the impact and no amount of sugar-coated goodwill could ever convince me that this was for the best. The lights up around me illuminate the reminders this time of the year. The moon is full over an ocean somewhere. It glows in perfect reflection of a certain peace, but I still sit with the loneliness. I still sit full of grief, memories, and days of the future that I can no longer have. I'm not a martyr, or at least I wasn't supposed to be, but this is my life now. I'm a singular situation remaining an ear shot away from Christmas carols. I've successfully isolated. It isn't a thing I meant to do. It just happened on one of the events that would change things forever. And now, the last three months of the year led me into an uphill

battle with my health when my automatic implantable defibrillator had its battery changed and developed an infection. What could've been a two-week quick procedure and healing turned into three months of hospital stays, treatments, and three different surgeries. Do you know what's worse than jingle bells in Starbucks? Jingle bells in hospitals in early November, that's much worse. I dig in the darkness. I want to feel my pulse. I need proof that I survived.

Talking to the Moon

Life Post Adoption, Suicidality, and Other Crisis

I imagine being home in Louisiana where I began. I'll stand near the doorway and dissect old family pictures. I'll halfheartedly smile at my father. I'll dig deeper for sincerity. My wishes will be silent yearning. The noise will drown out my thoughts and I'll remember where I am. There will be yelling. I don't know exactly why, but I'll remind myself that everyone is doing their best. Poverty lurks in southern Louisiana. I still wish on shooting stars for a big break. I don't want it as much as I want to give it away. This was my first home and I hold gratitude in combination with distance because of reasons I won't explain here. It smells like food I'm familiar with. As a child I had favorites here. I won't mention preferences. I'll oblige acceptance with each bite. No one will acknowledge the adoption size elephant in the room. We'll eat and the alcohol will overcome those who inhale it. The music will be a bang and I'll battle with internal monologues that beg me to be present. I'll smile politely and I won't say it, but I think they know a version of me from twenty-three years ago better than who I am now. I'll smile politely and I won't say it, but I can't wait to be on the freeway gaining distance and recharging the places within me that require peace. I try to keep my heart contained in my body as the beats intensify. It attempts to beat out of my chest in this pattern of bad habit. I embrace where I am as much as I can. I might want to drive for ten hours after hearing a Christmas song, but maybe I'll have more self-control to stay in the discomfort and face the Christmas tree-sized ache. Things are green and red. Snowflakes find me at supermarkets or I find them. I hold words inside of me. I accept what I know even

though biology doesn't have common knowledge. It doesn't care to listen in November when I'm a seasonal disaster, and desire to be understood. The words are with me, and I could write them in letters to mail, but they seem more comfortable as poetry that doesn't solicit responses. Even if I pour them out as cluttered messes, I'll find satisfaction in that. November exists and I don't have the power to change it but maybe I won't run. I'm forever reaching for warmth in this life I have now. Hope doesn't seem to stay either. The temperatures make it challenging, but I still do my best to read the corners of each room.

FOUR

I Think the Error in That Era Continued

The heaviest things are the things you can't put down/ the parts
of grief that follow you for a lifetime/ the parts that are
embedded despite any time or distance/ these things ache the
most/ People can ignore me, but I can't ignore the weight of
yesterday/ And it's a hard thing to sit with/ And I'm a hard
person to be near when I'm falling into the hollows of
yesterday/ but I understand/ I understand when people leave/ I
understand the silence/ I understand intentional distance/ I
understand the stares/ I understand the questions/ I am a
question/ one sided sad story/ prolonged deep pain/ the person
we don't talk about happiness with/ The person we bury our
family conversations around/ the person we politely smile at/ it
hurts more in secret/ I hide whatever parts of pain that I can/ I
try to be lighter and take up less space/ I tell myself not to cry/
I tell myself not to cry/ I tell myself that I'll survive another
December/ I tell myself not to cry/ I smile politely/ I look
away/ I know they're uncomfortable/ I'll be better/ I'll be
normal/ I'll be present/ I'll be in today/ I'll be present/ they
whisper/ they know I am melting away into sadness/ they don't
know what to do/ sometimes someone holds my hand/ but then
they let go/ it's been long enough/ and I break apart in the same
ways as before/ the grief is a mouth/ it is swallowing me/ they
look away/ and I understand

There's Always Going to be a Better Way to Say This
I Think the Error in That Era Continued

I think about suicide a lot. As an advocate in the mental health field, I've learned that there are two ways ideations can exist. There is suicidal intent and suicidal desire. The difference is in an individual's means to follow through with an active plan as opposed to the individual's desire to simply be dead and that yearning for some semblance of peace. After a couple suicide attempts, I've learned a lot about self-destruction and the ability to reassemble following hospitalization. I don't say this with shame for myself or anyone else who's ever been there. I've heard the secretive and near shameful language concerning suicide. I've watched as suicide continued to be tucked away like a dirty secret. As a society we can be so afraid of honesty and reality. We aren't having courageous conversations as much as we need to be. There's this misconception that talking about suicide encourages it, endorses it, or somehow provokes it. This is false. I wonder how many lives can be saved with an open and safe place to speak freely about mental illness, trauma, and/or ideations. There's a spirit of fear, offense, and judgment that exists in the stigma. And despite what we go through it's hard to reach out especially where division and shame exists. We walk so lightly around the important conversations that we should be having, so if you're reading this and you need to talk, I'm here. I extend my time and my heart out to you, sincerely. I'll share space wherever needed because I know the hurt. In my moments of despair, I fall deeper into my feelings after I feel unable to lean in any other direction because of isolation and the fear of being judged. Isolation during despair can be fatal.

As a human who stumbles I've avoided some heavy conversations myself. But I've learned that I avoided those interactions due to the worry that I wouldn't have the right words to say and some kind of tangible solution for the person who needed support.

However, I've also learned that when I'm in despair and on the end of needed support all I want is for someone to be present. I don't expect answers or some kind of magical support. I just wanted a presence and to feel less alone.

I think about suicide a lot and in my worse moments of decline I've clung to that place at the edge of life. I'm not alone in that place. I know this because I work in mental health, and I've witnessed the crisis that could have been prevented by a safe place to process without fear of shame or hospitalization. Let me be clear, we have no way of knowing the outcome in definite ways, but the change starts with asking are you okay, maybe even twice for the honest answer. The change starts with the effort we minimize at times. I'm in no way "making excuses" for suicide or romanticizing it. My intention is to hopefully convey insight into a decision that isn't immediate. It's more of a gradual disappearing. Furthermore, in terms of hospitalization, this can be more traumatic than the event occurring for someone with ideations. I've learned, and I still believe that we should determine if it's desire or intent. Be a safe place. I promise you, it matters.

I know personally that I've thought about suicide until I'm a sobbing mess and debilitated by the weight of it. Life can be so hard. Nobody asks for sadness or chooses how and when to be

sad. We can't control it. I've heard people say that suicide is the easy way out, but I disagree with that. Suicide is the hardest way out. Suicide is that internal war where you exist inside of flesh you merely want to crawl out of. Suicide isn't easy. Suicide is hard. Be present with and for someone today. If you're reading this and you've felt like you're on your last lifeline I'm proud of you. Please keep going.

Grief is a Disappearing Act

I Think the Error in That Era Continued

She vanished and those she's known prior were suddenly lifetimes away. She's absent most days and the distance is a cloud that feels as real as anything else on this planet. The sensory of touch grasps each moment and her fading existence is no different. It's real. Please tell me how you picture home. Can your heartbeat without that center piece of purpose encouraging it to drum life along? I genuinely wonder if they'll ever see her again and really see her in the shades of blue, she blinks in privately from galaxies away. How on earth will she ever get back to the flesh of her body and beat of a steady heart today? Yesterday and tomorrow are worlds apart and I think one more step will land her into the hell depression can be. I suppose that falling and staying down are two entirely different things. I wonder too many thoughts that collide into worry like thunder. I wonder if gravity is that thing keeping her under. I wonder about rip tides and after life. I wonder if she'll stand again after one more hopeless night. What if she's not strong enough to come back? What if she is an indefinite disconnect? The hardest lessons are often places where perseverance grows. Fighting becomes a choice and sometimes the answer is no and the heart refuses to go any further than it already has. White flag. White flag. She's merely a sinking tragedy and woman gone mad. Too bad. Tomorrow wasn't finished composing the breath needed in the next parts of her story. What a shame, intangible healing, and glory. Poor her. Poor me. The reflection is a shattered mess and as I talk to myself, I lose sight of hope on the map. It's possible to get lost and never come back. She knows pain well and I know pain just like that.

ELUSIVE

I Think the Error in That Era Continued

Here, I sit in the deepest and darkest corner of midnight
holding my shattered heart.
I wade in the seconds and minutes that we exist entirely too far
apart.
Still, I reach for you—
Understanding how hope feels within the pitch-black silence.
Still, I reach for you—
Hating how loneliness feels and resenting the parts of this hate
that's related to violence.
Here, four chambers beat into unbearable ache.
Here, in the still of midnight I've forgotten how to pray.
Still, I reach for you—
Understanding that you're the only source of healing for my
aching soul.
Still, I reach for you—
The night drags on and my body gets cold.
The stars are sprinkled across the sky like promises that no
longer make sense.
Hope feels like a prayer cried out into the night by a heart that's
no longer convinced.
Still, I reach for you—
Understanding that I may find disappointment in more places
than I find relief.
I'll reach for you—
Holding midnight's seemingly eternal hand where I'm
consumed by grief.
Here, I sit as a singular existence burdened by the heaviness of
regret.

My thoughts are an ocean alone—
Depths of regret I can never forget.
But still, I'll reach for you—
Understanding the nothingness, I'm likely to always own.
I reach for you—
Knowing that the heart is a garden of hope and that I'll always
be your home.
I reach for you—
Understanding that even if I am left with one tiny line of hope.
I'll reach for you—
Knowing that I must breathe until my last breath, and this is
how I cope.

First Aide

I Think the Error in That Era Continued

I watch the clock hoping time changes. Ideally, I'd like it to be 5:30pm on December 28th of 2017. But I've fallen so far into a life that I never wanted I'll settle for 3am or whatever time I fall asleep. I'll settle for whatever hour brings temporary relief. I'll settle for a place I can drift without having to sit awake in a body that I hate with decisions I regret in my rearview. The time never changes as quickly as I want it to, and it never goes back. It never brings me closer to you. I write these words as if you can hear me. But I know you're sadly nowhere near me. All I have is empty spaces and distant faces. Someone slide me a Band-Aid. My past is bleeding again.

The Time I Went to See Frida's Art and I Missed You All Day

I Think the Error in That Era Continued

I wrote about you today. I don't know what else to do. I spend my days picking apart memories in my mind and desperately searching for you. This city feels so cold. Broken fragments loosely hang on to who I've become. The wind blows and seasons change but this grief dug hole isn't done. I'm knee deep in the hollows of what was once a breathing existence. I place my hand on my heart and that beat that happened near you, I really miss it. These days I slip in the despair that leaks from the whole of my flesh. I'm an unsteady, too heavy, human puddle of a mess. September marks an anniversary for our little fallen star; our dearest dream, little twinkle, shines wherever you are. My heart is a hollow dark room where the echoes scream. Tears flow as despair filled water pulls me into a defeat downstream. Our future was a promise as sacred as religion holds its church. And for all it's worth my apologies overflow and I am forever cursed to rebirth the hurt. I reach for you and wish to hold you dearly. I hope you know that I'm sorry, I'm sorry, sincerely. I wrote about you today. I don't know what else to do. I spend my days picking apart memories in my mind and desperately searching for you. But my sweet friend had a remarkable day, and this was one of those times I wanted to be okay.

My Late Revelation

I Think the Error in That Era Continued

Family preservation is important. Heartbreak finds so many families who simply lacked resources to sustain and remain together. Vulnerable parents are taken advantage of more than society recognizes. It's our responsibility to do better as a society and human beings who are capable of wholehearted compassion. Children shouldn't suffer a trauma due to poverty and issues that are solvable with resources and the right support. Family preservation should be the goal.

The Pieces are Sand Through my Fingers, I Can't Pick These Up

I Think the Error in That Era Continued

The continuing point following adoption placement is immeasurably heartbreaking. There are so many nights where I break and break. I've been unable to move past the pain. Tonight, I'm in pieces and I've poured every bit of fight that I have out of me. There's nothing left. I'm voided and empty. I'm a birth mother who lived eight years as a mother before voluntarily signing papers that surrendered my children. I surrendered my entire heart and the magnitude of despair this brings is indescribable. I understand that I can't logically and accurately describe an adoption story that isn't mine alone. I'm one piece of a triad, but I'm the one holding the weight of a decision that no one has ever wanted to make. I say this in the context of accountability. If adoptive families are the saviors and saints, what are biological families? What am I as a birth mother? I'm significantly new to the birth parent community but I've seen this role unravel enough to know that the blame is with birth parents. We aren't questioning the birth certificate access issue for adoptees, we aren't looking at the money adoption costs, we aren't questioning this business transactions where poverty is the number one cause of placement, we aren't questioning ethics or lack of, and what about compassion? We aren't talking about family preservation. We're monetizing a family crisis, and by we, I mean society. We've normalized what is essentially life in the baby scoop era. Our placement wasn't due to lack of love or desire. The placement was due to lack of resources and support. Birth mothers experience high levels of suicidality and tonight isn't a proud moment.

December 28th will mark five years and there's a hole in my heart where life should be. There's a place for brokenness only birth mothers know, and I've too often placed myself in the reckless hands of those who couldn't possibly understand and disappointed friends who sincerely wanted to. I'm healing in the least bit of privacy because it is safer than being alone. I am transparent in ways that have hurt me and I'm stumbling very publicly to avoid isolation. It's a choice. My voice can't carry shame. I'm stepping forward because Houston, we really do have a problem and I'm pleading that we all see it. This isn't a private issue so please hear my cries and understand the importance of family preservation. Please hear my cries and understand the importance of mental health education, treatment, and support. Please understand the damage of judgment. Please understand the fragility of a birth mother's heart and all who've suffered any grief in general. Please understand the damage of violence and financial despair. Please understand that as I write this breaking tonight, that I was once living a completely different life. Please understand the unfamiliarity of my reflection every morning and the condition of life following placement. Please understand the trauma this was to the children I desperately wanted to parent. The adoption process often leaves birth mothers and first families to pick up the pieces and it's expected that we move on and live. But I can't.

IN HER SHOES

In Her Shoes/In Their Shoes is an experiential learning activity. Based on the experiences of real survivors, participants engage in a simulation in which they walk in the shoes of the various characters experiencing abusive and controlling relationships.

In Her Shoes helps spread awareness about the different ways violence manifests in the daily lives of those who experience it and brings us face to face with the multitude of challenges faced when seeking help. The toolkit represents an important step for long-term work of changing the attitudes and beliefs that condone violence against women. Stories include sensitive subjects directly from survivors who have experienced violence.

It's very rare for someone who hasn't placed a child for adoption to understand how it feels. There is usually a long series of events that led to that decision. This was absolutely the case for me. Even so, the consent doesn't feel like consent, looking back. In fact, when you participate within an "IN HER SHOES" activity you experience making decisions while going through abuse. For example, in option one you may need to choose between going to work after an altercation and assault or telling a friend, family member, or anyone in your immediate circle. We see a plethora of different outcomes. At times going to work or school led to shame or judgement instead of support. However, there are scenarios where decisions like going to work lead to harassment from the perpetrator and loss of a job for the victim. The survivors who shared these stories are real and the outcomes were unpredictable. No situation was the same. Just as, no situation is the same. Which hopefully portrays to participants involved that there is no cookie cutter sure way to exit these situations. Survivors couldn't "just leave," In fact, there are real consequences to consider before leaving. Furthermore, studies have shown changes in the brain following trauma, and these impact survivors greatly. When placed in these scenarios the goal is to show those who participate what it's like to walk in her/their shoes. This has plenty of benefits

including minimization of victim blaming and increased trauma informed awareness.

The adoption wasn't a snap decision made recklessly. I didn't sign over parental rights mindlessly. I genuinely thought it was the last resort. I wasn't equipped with the resources to know better or to access options that were tangible at the time. This series of events and decisions were because of the impacts of domestic violence. I wouldn't expect anyone to automatically understand this without placing themselves in my situation.

Those who haven't been *in* our shoes are not in a position to judge, but it happens. I know from a logical standpoint that the opinions are weightless and irrelevant, but they still hurt. The words have been blades that leave a wound long after they've left. I know these people have simply been another face with an opinion about a place they've never been to, but combined with the trauma of adoption and previous traumas it gets heavy over time. The grief is unending. That place inside of me where I was so unbelievably naive is still so foreign to me. There's a fog that forgets where the coffee counter was in proximity to the table where I signed away my parental rights. I can't believe that day even existed. But I'm not ashamed for feeling it. I'm not ashamed for the human in me that experienced trauma and surrendered to the wrong people. I've learned that their position is where the shame belongs. Of course, I wish I felt stronger. Of course, I would love to revoke my consent.

I regret it every waking second of every single day. But I still feel the shame belongs to the professionals involved that were paid to provide a service to seeking parents and utilized a vulnerable ~~victim~~ survivor of domestic violence and newly

194

single mother to do that. The system is created to fail families like us.

Surely, I'm not anti-adoption but I am anti-manipulation and coercion.

These were licensed professionals who didn't talk to me about family preservation. They didn't offer any resources. In fact, I asked to go back to the domestic violence shelter I was staying in with my children during that time and I was urged to continue signing. In fact, a week after signing and still having 23 days to revoke my consent I tried to back out and these professionals threatened me with social services. In fact, even while I reached out from a place of duress, they hovered until the papers were signed and the thirty-day time frame to revoke consent had passed.

in fact

On the night of signing, they urged me to sign the waiver that revoked my parental rights in 24 hours.

Did I reach out to the agency initially? Yes. I was on what felt like my last lifeline. Did we need help? Yes. We did. However, in no way shape or form was this ethical. This wasn't okay. We deserved better. I felt and still feel so robbed. I have children in this world that I want to parent. I miss them every day. Do you agree that poverty is penalized? Can I even go a step further and admit that we live in a country where poverty is criminalized? This is a discussion that should take up more space than it's permitted to. I married the wrong man. I was poor. This is my experience as a survivor and single mother who needed

resources and efforts for family preservation. I can't speak for the LCSW and everyone else involved but I know my experience and the experiences of other birth moms who've shared with me, that I won't elaborate on. All we needed were resources. We needed help maintaining our family.

Instead, our vulnerability was capitalized on and used as monetary gain. Sure, I signed consent but let's paint that picture further and clearly. I signed consent teary-eyed and unable to read or understand the papers I was signing. I signed under extreme emotional duress.

Is this still considered consent?

I work as a domestic violence community outreach advocate now, and I've trained for the certification to work with survivors of sexual assault as well. We learn what I hope society learns more of regarding consent. Consent cannot be persuaded. Consent cannot be coerced. Consent can change at any point during the encounter. Consent isn't a negotiation. Consent can only occur when the person who gives it is cognitive enough to give it without use of force or substances. Consent is given freely without use of pressure or threats. Consent cannot be given freely in unequal power dynamics.

But yes, I signed those papers.

Is my signature during that point in my life still considered consent?

Private Adoption

The total cost of private adoption depends on whether a family chooses to adopt through an agency or independently. Overall, the cost to adopt with an agency ranges from $30,500 to $48,500. To adopt independently, the cost ranges from $25,000 to $38,000.

Biologically humans are wired to bond with their mothers, and the neurobiological processes for that bonding begin in the womb. This is why all adoption is developmental trauma, even when the child is adopted at birth. How much, and in what way, these traumas manifest are as different and unique as each adoptee, and some may not feel it at all, but grief is in their bones and fight or flight is in their nervous systems.

The reality is, there are far more hopeful adoptive parents in the United States than there are children needing adoption, and the majority are those hoping to adopt a newborn. I believe that, as long as this is the case, and there is money to be made, there will always be unethical people, agencies, and practices to meet the demand. This must change. Children are not commodities that can be acquired. There really is no need for more adoptive parents. If you want to help a child, do something to support a parent in raising a child. Many wouldn't choose adoption if they had the emotional support and financial resources to parent. Oftentimes, relinquishments happen due to poverty and misfortune. Women who've experienced violence and landed in desperate and vulnerable positions can still want to parent. The abuse they experienced doesn't and won't make them a bad parent. If they have an immediate family and support system that doesn't support their right to parent, it doesn't mean that they shouldn't parent. The fear they experience during a new and/or unplanned pregnancy doesn't mean they don't want to parent or shouldn't. Poverty shouldn't be criminalized. Misfortune

shouldn't be capitalized on. If you want to help, become a foster parent who does everything they can to support children in returning to their family. This is how you do what's in the best interests of the child/children. If you want to help, give birth parents who inquire (or that are sought out) an opportunity to have all of the information. Let them speak to adoptees who are allowed to tell their truth without being attached to an agency or organization that filters what they say. Let them speak to birth mothers who are allowed the same space to be honest without any pressure of helping agencies acquire and convince vulnerable parents with an only positive narrative. There's a huge misconception that biological parents who place don't want to parent, but to be very candid, I signed with tears in my eyes, falling to the signature line, all while being rushed through the process. This isn't consent, is it?

I am not anti-adoption, but I do promote family preservation as a birth mother whose experienced systems in our society fail to promote and support family preservation. In regard to foster care, the primary goal should always be family preservation. Caseworkers should do everything possible to support that goal. People signing on to foster parent should not do so with the goal of a more affordable path to adoption. With that said, private adoptions should not coerce, manipulate, pressure, and lead vulnerable biological families into placement by threatening foster placements and child protective services reports in order to finalize signatures to obtain a child/children. This is one of many tactics used to coerce signatures once biological parents doubt placing.

In my experience, I survived domestic violence and attained temporary two-year housing that lasted the duration of court

hearings while battling safety and advocating for the wellbeing of both my children and I. I walked away with final custody and a permanent restraining order. At the end of that two-year period despite seeking other options, pursuing programs, and going as far as volunteering to make connections, we were vulnerable and struggling to find housing. This is where I surrendered parental rights. Society villainizes birth parents and makes poverty and being a victim of abuse into a personal failure when it is in fact a system failure.

A mother who parented for over eight years and doesn't have her children somehow translates into "an abusive mother", "an inadequate mother", amongst other unsolicited feedback I've received. And adoptive parents are seen as saviors and saints because they had the resources and a desire to adopt. Should we unpack that?

Some people with religious beliefs say that god called them to adopt. I believe that people feel inspired by the god of their faith, but I don't believe that adoption is god's perfect plan for any child. I in no way want to disrespect anyone's belief systems, but to me this feels like saying that god placed a child in the wrong womb simply to experience a trauma in order to get them to the right family, and that doesn't seem like a kind or just god. Obviously, this isn't the only reason you'll hear adoptive parents give, but it is at the core of adoption trauma and it's a weight that makes adoptees feel as though they shouldn't feel grief or wonder about and desire a connection to their biology.

I am just one part of a triad, but I've sat a long while with my own grief and the decisions and events that resulted in adoption. I've dissected and sought explanations and reasons. I've wanted

to understand how my decision impacted my children and the only way I've seen to do this is by speaking with adoptees who've experienced this. I've sought conversations with adoptive parents and contemplated their part in it. I've found there's a disconnect about the knowledge we have regarding what adoptees go through and have experienced. With this, I want to encourage you to read this with an open mind and heart and consider the possibility that adoption isn't a blessing. Again, I am in no way anti-adoption, but adoption isn't the only solution, nor should it be the first option, especially if there are other areas we can triage and support in order to prevent it.

The last thing I'll say is that in cases of adoption being a necessity, there should be no secrecy in adoption. On the outside of adoption, you wouldn't know about the secrecy or what it's like to have your biology buried and hidden from you. These individuals wouldn't conclude or know that adoptees have to have their initial birth certificate legally changed, won't experience the feelings of betrayal at not having access to their history, often resulting in their biology ultimately being erased in order for them to have their basic needs met. This shouldn't be the case, but it won't be defined as the developmental trauma that it is unless a part of the adoption triad helps inform outsiders of this. Secrecy and similar restrictions can even come up in open adoptions. When the open relationship is micromanaged and limited, it withholds certain information and prevents authenticity of sincere relationships between adoptees and biological families. A relationship should have a natural flow, and like adoption, anything restrictive of this goes up against the natural intention of human existence. Outsiders wouldn't think about how being lied to about your identity and the adoption

only contributes to the trauma. Adoptees have every right to know the identity of their first parents, siblings, and extended family. In addition, siblings and extended family have a right to know the existence and identity of a child placed for adoption. Adult adoptees should have easy and full access to unchanged records of their birth, as well as their original birth certificate. Currently, that is not the case. They have every right to know their identity and heritage just like anyone else. Secrecy and attempts to control the narrative prevent adoptees from knowing the truth and having an opportunity to develop their own feelings and thoughts about it.

Adoptees weren't given a decision in the placement, and we should work to empower adoptees and become alliances in elevating their voices.

Afterword

I've sat under streetlights on and off for years. I've sat, ghostlike, and lonely with the weight of a decision no one should have to make. I sat surrounded by the metaphorical debris this aftermath has been. My signature haunts me, and I break mirrors with the magnitude of self-hatred that it's conjured up for me. My heart still beats. In broken fragments, it carries me forward. The repetitive ways my body continues, urge me to look ahead at a future, and the only way I can do this is by unpacking the pain and injustice in these pages.

I remember the little community that existed together in every parking lot I've ever slept in. There's something about knowing you aren't alone in situations like those that is both terrifying and settling at the same time. It wasn't so much the people I couldn't trust. The people reflected the parts of me that needed resources, love, unconditional support, food, money, shelter, and understanding, among a long list of other commonalities.

Sure, there are survival habits that are learned as a way of coping, but there are people who exist in our world that had an entire life before whatever unfortunate thing (often a series of things) led to their homelessness. And despite the stigma that connects homelessness to drug abuse and crime, there are people somewhere in your community without a safe place to sleep and that is worth some reflection.

They aren't automatically bad people you can't trust. More than anything, I couldn't trust that dire hunger and that urge for basic needs to be met, but the places I slept were steady. I did practice precautions every day, but that's just common-sense, stuff I'd do whether I lived in a car or house. I remember the community and feeling understood. It isn't all bad, but it isn't

something I'd endorse as a chosen lifestyle. Lots of displaced people experience assault and trauma on top of the trauma of experiencing homelessness. Though there were scary nights, my experience wasn't as bad as I witnessed some others to be. I had interactions with the men who camped out in those parking lots. At first, fear was the only thing I recognized, but then it became clear that there were regulars who looked after their own. And I was in there. After years of living in a home with my abuser, here I am sleeping in a parking lot being looked over by well-meaning and safe men. I was a regular. There I was with this situation, this story, this tragedy, and I didn't have a home to call my own, but I had a car and reserved place in this faceless community. We saw and understood each other even when the rest of the world didn't see us. We carried our space with silence and caution. And dare I say, a certain security and a slight peace of mind. We minded our own business, and there was a certain surety that after battling our days we'd return.

I'm sharing these words with the world because of the nights I spent under streetlights as this nameless woman without a home. I'm sharing because of oppression and injustice. I'm sharing because privacy and silence are often mistaken. This transparency, even in a small wave, is my way of calling readers to action. These words found me in my dreams under those streetlights and they're tangible in these pages now.

Why chrysanthemums? Chrysanthemums symbolize different things in different cultures. They bloom in different shapes and colors. There are thousands of chrysanthemums available today, but this flower started as a simple bloom. The first originated in East Asia, with the majority coming from China. One of the first notes of chrysanthemums came from the philosopher Confucious. He mentioned them in his works

thousands of years ago. The chrysanthemums later were found in Chinese traditions and among Buddhist monks.

In time, they made their way to the western world. Their meanings vary depending on where you're located. A flower that symbolizes happiness in one place may relate to death in another. In Australia it is the official Mother's Day flower, mums. In Belgium and other western European countries like France and Austria, chrysanthemums symbolize death. In China they relate to a long life and good fortune. The white chrysanthemums usually relate to grief, red reflect love and passion, pink is often for friendship and affection, orange is associated with good feelings, yellow reflects joy and happiness, green are uncommon but represent rebirth, good health, and longevity, and purple represent well wishes, thoughtfulness and caring.

I chose this flower and this title because of the various meanings of chrysanthemums. During the first four-and-a-half-years post adoption I lived in my car, although on and off. The seasons and feelings fluctuated exponentially. I found myself in a devastating version of my life. My heart was broken. I lost my entire identity. I lost my family. It was lonely and, on the nights, I cried I genuinely felt like the sky was falling because of the pain. My life had stopped. Parts of me died, but my heart kept beating. In those years, I grew as a person in the most challenging and earth-shattering ways. But I found myself even while in the ashes of yesterday. We don't talk about the transition out of abusive relationships enough. Life after the emergency shelter is a private experience but it takes years to rebuild lives. The chrysanthemums represent the seasons I experienced, whether new friends or job losses. They represent the night drives to the beach and learning to walk after picking up my own pieces. They represent an entire life happening

while sleeping under streetlights at a twenty-four-hour Planet Fitness or Walmart. Chrysanthemums represent living long, after I felt I had died. These flowers represent all that's unraveled, and the perseverance breathing has taken. They represent all that has gotten me to where I am now as I share these words, and I hope they will act as a call to action. I hope you're able to see these injustices and support one another when stories like these arise. I hope my transparency paves a way toward safe places for others to feel heard and understood. I hope we're able to call out systems which are unjust in our communities and fight together to provoke one change at a time. And I hope that anyone in pain who reads this feels less alone and able to continue, despite whatever storms they face.

The 988 Suicide & Crisis Lifeline (formerly known as the National Suicide Prevention Lifeline) offers 24/7 call, text, and chat access to trained crisis counselors who can help people experiencing suicidal, substance use, and/or mental health crisis, or any other kind of emotional distress.

References

❖ The National Center on Family Homelessness. (2011). The Characteristics and Needs of Families Experiencing Homelessness. *Available at* http://www.familyhomelessness.org/media/147.pdf

❖ Bassuk, E. (1995). Lives in Jeopardy: Women and Homelessness. In C. Willie, P.P Rieker, B. Kramer and B. Brown. Mental Health, Racism and Sexism. Pittsburgh: University of Pittsburgh Press, 237-252

❖ National Law Center on Homelessness and Poverty. (2010). Some Facts on Homelessness, Housing, and Violence Against Women. *Available at* http://www.nlchp.org/content/pubs/

❖ Bassuk, E. et al. (1996). The Characteristics and Needs of Sheltered Homeless and Low-Income Housed Mothers. Journal of the American Medical Association 276(8): 640-646. *Available at* http://jama.amaassn.org/content/276/8/640.abstract

❖ National Women's Law Center. (2011). Analysis of New 2010 Census Poverty Data—September 2011. *Available from* http://www.nwlc.org/analysis-new-2010-census-poverty-data-%E2%80%93-september-2011

❖ National Women's Law Center. (2011). Closing the Wage Gap is Especially Important for Women of Color in Difficult Times. *Available at* http://www.nwlc.org/resource/closing-wage-gap-especiallyimportant-women-color-difficult-times

❖ Zlotnick, C. et al. (2010). Long-Term and Chronic Homelessness in Homeless Women and Women with Children. Social Work in Public Health, 25:470-485

❖ Center for American Progress. (2009). Unmarried Women Hit Hard by Poverty. *Available at* http://www.americanprogress.org/issues/2009/09/census_women.html

❖ Cheung, A. et al. (2004). Risk of Death Among Homeless Women: A Cohort Study and Review of the Literature. Canadian Medical Association Journal. *Available at* http://www.cmaj.ca/content/170/8/1243.full

❖ National Network to End Domestic Violence. (2011). Family Violence Prevention and Services Act. *Available at* http://www.nnedv.org/policy/issues/fvpsa.html

❖ National Center for Injury Prevention and Control. (2010). National Intimate Partner and Sexual Violence Survey. *Available at* http://www.cdc.gov/ViolencePrevention/pdf/NISVS_Executive_Summary-a.pdf

❖ https://www.legalmomentum.org/history-vawa

❖ National Network to End Domestic Violence. (2011). Reauthorization of the Violence Against Women Act (VAWA). *Available at* http://nnedv.org/docs/Policy/VAWA_Reauthorization_Fact_Sheet.pdf

❖ National Network to End Domestic Violence. (2010). Domestic Violence Counts 2010: A 24-Hour Census of Domestic Violence Shelters and Services. *Available at* http://nnedv.org/docs/Census/DVCounts2010/DVCounts10_Report_BW.pdf

❖ https://www.womenagainstabuse.org/get-help

❖ https://www.mayoclinic.org/diseases-conditions/long-qt-syndrome/symptoms-causes/syc-20352518

❖ https://healthconsumer.org/hospitals-dump-patients-nowhere-go/

❖ https://www.cdc.gov/mmwr/volumes/69/wr/mm6950a8.htm#:~:text=During%202015%E2%80%932018%2C%20there%20were,the%20rate%20for%20nonhomeless%20persons.

❖ https://www.heart.org/en/health-topics/heart-valve-problems-and-disease/heart-valve-problems-and-causes/problem-heart-valve-regurgitation

❖ https://www.bbrfoundation.org/blog/homelessness-and-mental-illness-challenge-our-society

❖ https://www.originscanada.org/adoption-trauma-2/trauma_to_surrendering_mothers/adoption-trauma-the-damage-to-relinquishing-mothers/

❖ https://mariedolfi.com/adoption-resource/relinquishment-trauma-the-forgotten-trauma/

❖ https://www.samhsa.gov/find-help/988/faqs

CPSIA information can be obtained
at www.ICGtesting.com
Printed in the USA
BVHW030627250822
645498BV00004B/17